how to make good pictures

*an entertaining authoritative handbook
for everyone who takes pictures*

by the editors of
Eastman Kodak Company

Library of Congress Catalog Card No. 70-189808

ISBN Number 0-87985-021-3

contents

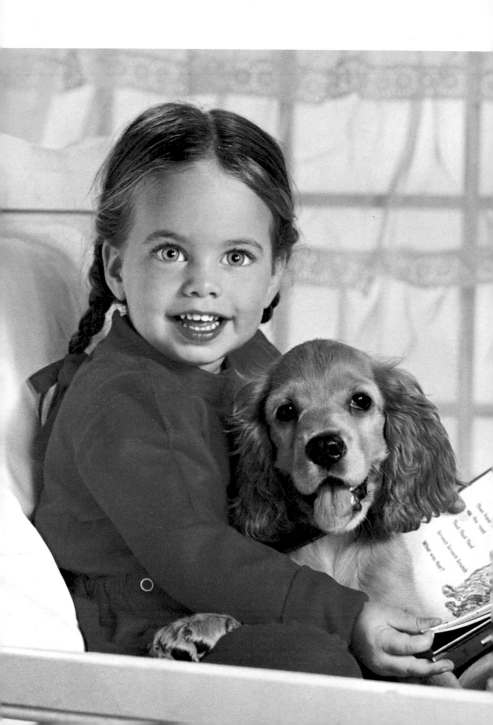

introduction

This is a book about pictures—the kind of pictures that most people like—pictures of their families, of the places they visit, and of the things they do and see.

This isn't a technical kind of book because, for most of us, technicalities and fun don't necessarily mix. This book simply points out some of the features that make pictures better than run-of-the-mill, and suggests ideas for shooting good pictures with the least possible fuss and expense.

The pictures it explores are snapshots—all kinds of snapshots of many different subjects. Is there a baby in the house? We have a whole section devoted to snapshots of babies. As the baby grows, you'll want to refer to the section on snapshots of children. Another section will show you how to take the best snapshots of Mom and Dad, and other grown-ups, too. The section on flowers will help you to enjoy your garden year-round, in your pictures. Going on a trip? The section on vacation and travel will help you to make the most of your picture-taking opportunities. Do you have a pet? Do you like sports? Or is scenery your camera's prime target? This book contains helpful hints on taking better pictures of all these things—and more!

Not only is this a book about pictures, it's also a picture book! The best way to learn what makes a good picture is to see lots of good pictures. (On the next four pages there are some samples of the kinds of pictures this book is about.)

Pictures indoors with
flash—page 25.

Pictures of family and
friends—page 34.

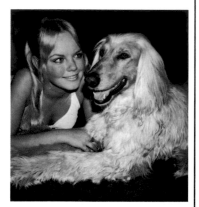

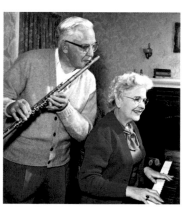

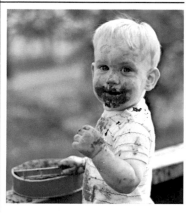

If babies are one of
your favorite picture subjects,
refer to page 38.

For pictures of children during
the middle years, from
ages three to ten, see page 52.

Want to take pictures of
grown-ups? Refer to page 66.

Vacations offer many
opportunities to
take pictures—page 77.

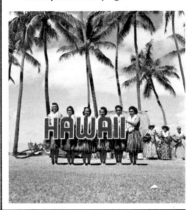

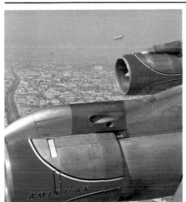

**You can take pictures from
airplanes—page 83.**

Do you want to take pictures
of scenics? See page 87.

Like pictures of sunsets?
See page 91.

If your pet is one of
your favorite picture subjects,
refer to page 112.

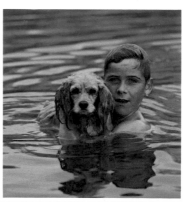

For pictures showing the
action, color, and excitement
of sports, turn to page 124.

Are you a flower fancier?
Pages 130 through 140 tell you
how to make dramatic
close-up pictures of flowers
and other small objects.

You can collect pictures of delicate items such as unusual glassware. See page 145 for information on glassware and other picture collections.

The Christmas season is a good time to put your family in pictures—on photographic greeting cards. To learn how, see page 172.

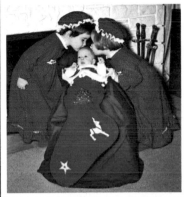

For unusual flash techniques that will make your pictures look professional, refer to page 148.

Pictures underwater? Why not! Turn to page 161.

Before we get down to picture-taking, let's take a brief look at the "tools" you'll be using. Just as the artist has to select his brush and colors before he paints a picture, you have to select your film.

SELECTING THE RIGHT FILM

Film comes in different sizes and in different types for different kinds of pictures. Most cameras can use black-and-white or color film and produce black-and-white prints, color prints, or color slides. Your end result, prints or slides, depends upon the type of film you put in the camera. See the chart on the next page. Notice that you can order color slides from your color negatives, and color prints from your color slides.

KODACHROME II, KODAK EKTACHROME-X, KODACHROME-X, and KODACOLOR-X Films are "general-purpose" color films. You can use these films for most picture-taking situations. KODAK VERICHROME Pan and PLUS-X Pan Films are "general-purpose" black-and-white films.

Some films, such as KODAK High Speed EKTACHROME and TRI-X Pan Films, are "special-purpose" films. Use these films when lighting conditions are poor: on a very dark day, indoors without flash, at stage shows. The high speed of TRI-X Pan and High Speed EKTACHROME* Films allows you to make pictures under these low-light situations. Because of their high speed, however, these extra-fast films should be used only with automatic or adjustable cameras.

*You can expose High Speed EKTACHROME Film at 2½ times the normal film speed with ESP-1 processing. This special processing service is available for film sizes 135 and 120 only. The cost of the KODAK Special Processing Envelope, ESP-1, sold by photo dealers, is in addition to the normal cost of processing by Kodak.

CHOOSING A FILM

Each kind of Kodak film is designed
primarily to produce only one of these
three kinds of pictures. Each film carton
tells you the kind of pictures that particular
film makes.

Color Negative

KODACOLOR-X Film is for COLOR PRINTS

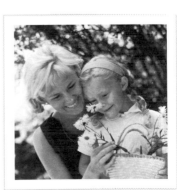

Color Print

**KODACHROME II,
KODACHROME-X, KODAK
EKTACHROME-X,** and **KODAK
High Speed EKTACHROME**
Films are for COLOR SLIDES

Color Slide

Black-and-
White Negative

**KODAK VERICHROME Pan, PLUS-X Pan,
PANATOMIC-X,** and **TRI-X Pan** Films are for
BLACK-AND-WHITE PRINTS

Black-and-White Print

11

LOADING AND HANDLING

Refer to your camera manual for the proper way to load your camera. Film is light-sensitive, so protect it from light. The only time that light should reach the film is when you take a picture. Any other light will spoil your pictures, so load and unload your camera in subdued light if you have a roll-film camera.

STORAGE

Store film in a cool, dry place. For best results, use the film before the date printed on the film carton.

PROCESSING

Film is one of those things that do not improve with age. For the best results, have your film processed as soon as possible after you finish a roll. Your dealer can have your color film processed by Kodak or another laboratory, or you can mail it directly to a processing laboratory with the appropriate prepaid processing mailer. Such mailers are sold at camera shops and drugstores. Color slides and color prints that are processed or made by Kodak are so identified.

A "HELPER" IN THE FILM BOX

There's a "helper" in most packages of Kodak film. The "helper" is a film instruction sheet, which some people throw away without a glance. (The cads!) This little sheet will help you to use your film properly so that you'll get the best possible pictures. The film instruction sheet is full of valuable information, such as the film speed to set on your automatic camera or exposure

meter, how to use the film in daylight or with flash, and how to get the film processed. You can process some films yourself, if you're so inclined. The instruction sheets for films that can be processed by the user contain information on home processing. The moral of this is "Don't throw your 'helper' away." Slip the instruction sheet inside your camera case or gadget bag, where you can refer to it when necessary.

DAYLIGHT PICTURES

FOR AUTOMATIC CAMERAS OR EXPOSURE METERS
Set film-speed dial on camera or exposure meter at ASA 25.

SETTING CAMERAS WITHOUT AN EXPOSURE METER
Use the exposure indicated below under the appropriate lighting condition.

DAYLIGHT EXPOSURE TABLE FOR *KODACHROME II* FILM					
Shutter Speed 1/125 Second				Shutter Speed 1/60 Second	
Bright or Hazy Sun on Light Sand or Snow	Bright or Hazy Sun (Distinct Shadows)	Cloudy Bright (No Shadows)	Heavy Overcast	Open Shade†	
f/11	f/8*	f/4	f/4	f/4	

*f/4 at 1/125 second for backlighted close-up subjects.
†Subject shaded from the sun but lighted by a large area of sky.
For ready reference, keep this table with your camera.

FLASH PICTURES

USE BLUE FLASHBULBS OR FLASHCUBES. Determine the f-number by dividing the guide number for your reflector and flashbulb by the distance in feet from the flash to your subject. Use these numbers as *guides*—if your flash pictures are consistently too dark, use a lower guide number; if too light, use a higher guide number.

For successful flash operation, clean battery ends and equipment contacts with a cloth dampened with clean water only. If the contacts are difficult to reach with a cloth, use a water-dampened cotton swab to clean them.

GUIDE NUMBERS FOR BLUE FLASHBULBS						
Type of Reflector	Flashbulb	Shutter Speed				
		X Sync	M Synchronization			
		1/30	1/30	1/60	1/125	1/250
	Flashcube	50	36	36	28	22
	Hi-Power Cube	70	50	50	40	32
	AG-1B	36	26	26	22	18
	AG-1B	50	36	36	30	24
	M2B	45	NR	NR	NR	NR
*	AG-1B	70	50	50	45	36
	M2B	65	NR	NR	NR	NR
	M3B, 5B, 25B	70	70	60	50	42
	6B†, 26B†	NR	65	50	34	24
*	M3B, 5B, 25B	100	100	90	70	55
	6B†, 26B†	NR	95	70	50	34

*Polished bowl. †Bulbs for focal-plane shutter. NR—Not Recommended.

Caution: Bulbs may shatter when flashed; use a flashguard over your reflector. *Do not use flash in an explosive atmosphere.* See flashbulb manufacturer's instructions.

How to Use the Film Instruction Sheet

The front of this film instruction sheet gives information on exposing the film in daylight or with flash. The **film speed** is listed at the top of the sheet so that people with automatic cameras and exposure meters can find it right away. (See page 17 for an explanation of film speed and how it is used.) If you don't have an automatic camera or exposure meter, the **Daylight Exposure Table** will help you set your camera for daylight picture-taking.

The "Flash" section of the instruction sheet includes a flash table and instructions on how to use it.

14

⚡ ELECTRONIC FLASH

Use this table with electronic flash units rated in beam candlepower seconds (BCPS). To determine the f-number, divide the guide number for your flash unit by the distance in feet from the flash to your subject. If results are unsatisfactory, change the guide number as described for blue flashbulbs.

Light Output of Unit BCPS	350	500	700	1000	1400	2000	2800	4000	5600	8000
Guide Number	20	24	30	35	40	50	60	70	85	100

ADDITIONAL INFORMATION

FILM SPEEDS AND FILTER RECOMMENDATIONS

Type of Light	Film Speed	Filter
DAYLIGHT	**ASA 25**	**None**
PHOTOLAMP 3400 K	ASA 8	No. 80B
TUNGSTEN 3200 K	ASA 6	No. 80A

NOTE: If your camera has a built-in exposure meter that makes the reading through a filter used over the lens, see your camera manual for instructions on exposure with filters.

If you use exposure times longer than 1/10 second, you may need to increase exposure to compensate for the reciprocity characteristics of this film. For information on this subject, write to the address given below.

AVOID CONDITIONS THAT SPOIL YOUR PICTURES. Load and unload your camera in subdued light. Don't keep your camera and film in a hot place, such as the glove compartment or rear-window shelf of a car. Rewind 135 film into the magazine before you open the camera back. For best results, have your film processed promptly after exposure to avoid changes in the undeveloped image. Store film and slides in a cool, dry place.

On the back of the sheet you can find out how to expose the film with **electronic flash**.

If you'd like to use the film with photolamps or tungsten light, a table on the film instruction sheet tells you whether or not you'll need a filter, and the film speed to use with the filter.

The film instruction sheet will also tell you if you can process the film yourself.

remember....

- For all-around color picture-taking, use KODACHROME II, KODAK EKTACHROME-X, or KODACHROME-X Film for color slides and KODACOLOR-X Film for color prints.

- Use KODAK VERICHROME Pan or PLUS-X Pan Film for black-and-white prints.

- You can order color slides from your color negatives.

- You can order color prints from your color slides.

- Load and unload your camera in subdued light.

- Use the film instruction sheet.

- Have film processed as soon as possible after exposure and before expiration date printed on carton.

- Keep film in a cool, dry place.

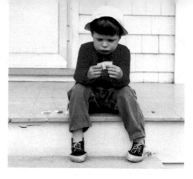

kids just being themselves

There are so many things to photograph in the daytime...

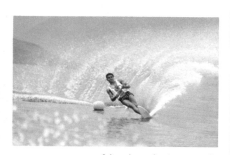

friends enjoying sports

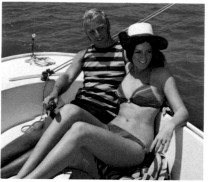

a country scene

family members enjoying a picnic

the tranquility of a harbor
in the early morning

This is a sort of "nuts and bolts" chapter for those who have some questions about camera settings. If you already know how to set your camera for daylight and flash picture-taking, you may want to skip on to the next chapter.

There are many kinds of cameras. You don't need a complex camera and a heavy load of equipment to take good pictures. Whatever kind of equipment you have, however, you should know how to use it, and what it can do for you.

SETTING YOUR CAMERA FOR DAYLIGHT PICTURES

You can get good pictures of all your outdoor fun if you use your camera correctly. That's what this section is all about . . . setting your camera for outdoor pictures.

Let's classify cameras into three main types: simple, automatic, and adjustable.

Simple Cameras

Most simple cameras don't have any adjustments. With a simple camera, you can take pictures outdoors on sunny days or you can take flash pictures either indoors or outdoors, by keeping your subject within a certain distance range. The camera manual will tell you what this range is.

Automatic Cameras

The thing that makes automatic cameras "automatic" is an exposure-control system. While you aim the camera and compose your picture, the exposure-control system evaluates the amount of light reflected from your subject and sets the camera for you. All you have to do is "tell" the exposure-control system the

17

speed of the film you're using. The film speed ("ASA") is listed on the film carton or the film instruction sheet. Your camera manual will tell you how to set the film speed. If you have a camera such as a KODAK INSTAMATIC® Camera, a notch in the film cartridge sets the film speed for you when you load the camera.

Some automatic cameras have a "fixed-focus" lens. A fixed-focus lens is set at the factory for normal picture-taking distances. With this type of lens, you can take pictures from about 4 or 5 feet to infinity (as far as you can see). Other automatic cameras have focusing lenses. With a focusing lens, you adjust the lens by setting the focusing scale for the distance from the camera to the subject.

Adjustable Cameras

Even the most complicated-looking adjustable cameras have only three basic settings: focus, shutter speed, and lens opening.

Focus: You focus an adjustable camera in the same way as an automatic camera—by setting the focusing scale for the distance from the camera to the subject. Some cameras have rangefinders to help you focus. With most rangefinders, you turn the focusing ring until two images line up in the viewfinder. When these images are lined up, the camera will be focused for the correct subject distance.

Some rangefinders have a split image, while others have two images.

When these images are lined up, the camera is focused for the correct subject distance.

18

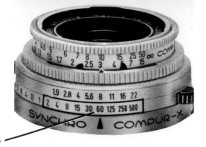

The shutter-speed markings on the camera represent fractions of a second.

SHUTTER SPEEDS

Shutter Speed: The shutter speed controls the *length* of time the light strikes the film. Shutter speeds are marked on the camera by such numbers as *30, 60, 125, 250,* and *500.* (Other cameras might have *25, 50, 100,* etc.) These are actually fractions of a second, and mean 1/30, 1/60, 1/125, 1/250, and 1/500 second. For practical purposes, shutter speeds that are very close together, such as 1/25 and 1/30, or 1/50 and 1/60, can be considered the same.

Changing from one shutter-speed number to the next larger one (for example, *60* to *125*) lets in one-half as much light. Or, changing to the next smaller number (for example, *60* to *30*) lets in twice as much light.

For most daylight pictures, you'll probably want to set your shutter at *125.* This shutter speed, 1/125 second, is the one usually recommended on the film instruction sheet for sunny-day pictures. It helps reduce the effect of camera movement, which is the No. 1 picture spoiler. Of course, it's still important to hold the camera *very* steady.

Lens Opening: The openings in your camera that determine the *amount* of light that reaches the film are called "lens openings." Numbers are used to indicate the size of these lens openings. These numbers are called "f-numbers." The following range of f-numbers is typical on most adjustable cameras: *2.8, 4, 5.6, 8, 11, 16, 22.* The smallest number on the lens refers to the

LENS OPENINGS

The smallest number on a lens refers to the biggest lens opening. The largest number is the smallest lens opening. When you move from any lens opening to the next larger one, you let in twice as much light. Moving from any lens opening to the next smaller one cuts the light in half.

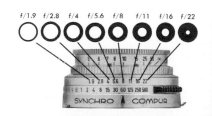

biggest lens opening. The largest number is the smallest lens opening. On the camera lens on page 19, $f/1.9$ is the largest opening and $f/22$ is the smallest opening. The distance between any f-number and its neighbor is called a "stop." So, changing from $f/11$ to $f/8$ would be opening the lens 1 stop.

As with shutter speeds, when you move from any lens opening to the next larger one (for example, $f/11$ to $f/8$), you let in twice as much light. Moving from any lens opening to the next smaller one (for example, $f/11$ to $f/16$) cuts the light in half.

On some cameras, you may find another lens-opening number—such as *4.5*, *3.5*, or *1.9*. These f-numbers fall between those in the regular series. Such a number usually indicates the largest opening on that particular camera.

Combining Lens Opening and Shutter Speed: Now you know what the numbers on your camera stand for: lens openings and shutter speeds. Let's see how to use these two settings to get well-exposed pictures. There are two easy ways to determine which lens opening and shutter speed you should use to get a well-exposed picture.

One way to determine the exposure is with an *exposure meter*. Many cameras have built-in meters, or you can use a separate meter. As with some automatic cameras, you must "tell" the meter the speed of the film you're using. As you know, you'll find the film speed on the film instruction sheet or the carton. After you've set the film speed on the meter, use the meter according to the manufacturer's recommendations. An exposure meter can indicate the correct exposure over a wide range of lighting conditions—which is a real advantage if you want to take pictures under unusual conditions, such as on a shady porch, in the woods, or indoors without flash.

Film Instruction Sheet: The other way to determine the expo-

sure is with the film instruction sheet. There's an exposure table on each film instruction sheet, giving the shutter speed and lens opening for outdoor lighting conditions from a bright, sunny day to a dark, overcast day. Use the shutter speed and lens opening listed under the lighting condition that is closest to the lighting on your subject.

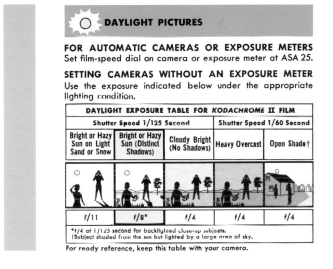

☀ DAYLIGHT PICTURES

FOR AUTOMATIC CAMERAS OR EXPOSURE METERS
Set film-speed dial on camera or exposure meter at ASA 25.

SETTING CAMERAS WITHOUT AN EXPOSURE METER
Use the exposure indicated below under the appropriate lighting condition.

DAYLIGHT EXPOSURE TABLE FOR *KODACHROME* II FILM				
Shutter Speed 1/125 Second			Shutter Speed 1/60 Second	
Bright or Hazy Sun on Light Sand or Snow	Bright or Hazy Sun (Distinct Shadows)	Cloudy Bright (No Shadows)	Heavy Overcast	Open Shade†
f/11	f/8*	f/4	f/4	f/4

*f/4 at 1/125 second for backlighted close-up subjects.
†Subject shaded from the sun but lighted by a large area of sky.

For ready reference, keep this table with your camera.

Let's review for a minute. Setting your adjustable camera is as easy as 1, 2, 3. (1) *Focus* for the distance from the camera to the subject. (2) Set the lens opening. (3) Set the shutter speed indicated by your exposure meter or the film instruction sheet. Just 1, 2, 3—and you're ready to take a picture. That's all you have to know to set your adjustable camera correctly. But, if you'd like to know how versatile your camera can be read on!

Using Various Combinations of Lens Openings and Shutter Speeds:
Many combinations of lens openings and shutter speeds will produce an equal exposure on the film. If you increase the lens opening by 1 stop (for example, f/11 to f/8), you can change the shutter-speed number to the next faster speed on the scale (for example, 1/125 to 1/250) to keep the exposure constant. It works the other way around, too. If you change the shutter speed to the next slower speed on the scale, you can decrease the lens opening to keep the exposure constant.

1/125 at f/11

1/250 at f/8

Why bother? Because you can make equivalent combinations of lens openings and shutter speeds work for you in two special picture-taking situations.

1. Stopping action. A high shutter speed such as 1/500 second will help you to take pictures of any fast action. To make sure that you get a good exposure, first determine the correct exposure for the lighting conditions (for example: 1/125 second at f/5.6 for KODACOLOR-X Film on a cloudy-bright day). Then change the speed to 1/500 second, moving the shutter-speed setting the appropriate number of stops from the normal position (for example: from 1/125 second to 1/500 second—2 stops). Make the lens opening larger by moving the lens-opening setting the same number of stops, but toward the lower numbers (for example: from f/5.6 to f/2.8—2 stops).

Small lens openings (like f/16) produce great depth of field; the whole picture looks sharp.

Large lens openings (like f/2.8) produce shallow depth of field. The subject is sharp, but the foreground and background are out of focus.

2. Using depth of field. The distance range in which objects in a picture look sharp is called "depth of field." You get more depth of field when you use a small lens opening (such as f/22) than when you use a large lens opening (such as f/2.8). Remember, when you change the lens opening to get more or less depth of field, you have to change the shutter speed by the same amount to keep the exposure equivalent.

You can use depth of field as a "control" in your pictures. In some pictures you may not want everything to look sharp. For example, an out-of-focus background often accentuates the subject in a close-up view. You can get this effect by using a large lens opening, which produces a shallow depth of field and throws the background out of focus.

In scenic shots—where you want everything to appear sharp —use a small lens opening for the greatest depth of field.

Many adjustable cameras have a depth-of-field scale on them that indicates how much of the scene will be in focus at each lens opening. Any subject within the depth-of-field range will appear sharp.

One of the big advantages of having an adjustable camera is being able to use equivalent exposures to control your results— it pays off in better pictures.

23

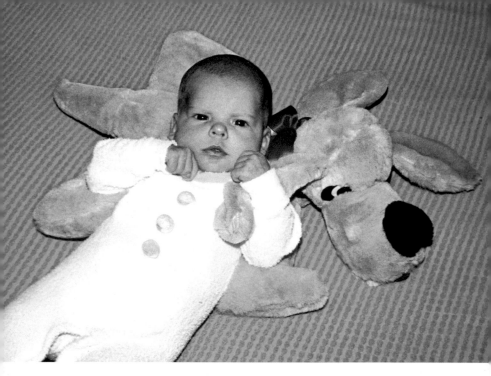

Think of all the happy things that happen in your home:

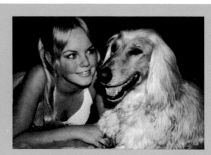

family gatherings

parties

new babies

kids finding surprises on
Christmas morning

the whole range of events that
make life fun

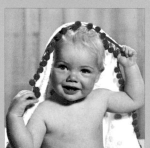

They all can be captured and treasured forever in flash pictures.

SETTING YOUR CAMERA FOR FLASH PICTURES

For the best possible flash pictures with your equipment, read your camera manual and use the information on flash in the film instruction sheet.

Your camera manual and the film instruction sheet will give you useful information on how to take the best possible flash pictures with your equipment. The camera manual will tell you what size of bulbs and batteries to buy and how to adjust your camera for flash picture-taking. The film instruction sheet will tell you what settings to use to get the best flash pictures with that film.

Types of Flash

To make flash pictures, you need some sort of flash equipment. Here's a quick look at the kinds of flash most people use.

Flashcubes: Flashcubes have made flash picture-taking more convenient and easier than ever. You just pop the cube onto a camera that has a flashcube socket, and you're ready to snap four flash pictures without ever touching a flashbulb! Each cube is a complete flash holder containing four blue flashbulbs. Flashcubes can be used only on cameras having a flashcube socket or a flashcube adapter.

Magicubes: Magicubes combine the convenience of flashcubes with an extremely reliable flash system. This new flash system is more reliable than any previous system because it doesn't depend on batteries for power. (Corroded batteries and camera contacts are the biggest cause of flash failure—see page 28.) Although magicubes look similar to flashcubes, they are not interchangeable. Magicubes are slightly larger than flashcubes; they have an "X" on the top of the cube and four open slots on the cube base. Use magicubes only on cameras that are designed for them, such as the KODAK INSTAMATIC X Cameras.

Flashbulbs: These come in two colors—clear and blue. Use blue flashbulbs with Kodak black-and-white and color films. You can use clear flashbulbs with black-and-white films, but it's usually more convenient to buy only blue bulbs. Flashbulbs fit into built-in flash units on some cameras. They also fit into flash holders that can be attached to cameras. Your camera manual tells you whether you need a flash holder in order to take flash pictures. To learn what size of flashbulb to use, consult the camera or flash holder manual.

Electronic Flash: This is the third type of flash you can use. It's fairly expensive compared with the other types, but has certain advantages. Electronic flash attachments accept a special lamp called an "electronic flashtube." You can get thousands of flashes from one flashtube, and the burst of light from a flashtube is much briefer than that from a flashbulb. This extremely

"short" flash duration allows you to use any shutter speed with leaf-type shutters. (Check your camera manual to see whether your camera has a leaf-type or a focal-plane shutter.) Electronic flash is great for "stopping" fast action. The camera manual will tell you whether you can use electronic flash with your camera.

For more information about electronic-flash equipment, see your photo dealer for a copy of Kodak *Publication No. AC-2,* Flash Pictures.

Exposure with Simple Cameras and Many Automatic Cameras

Getting the right exposure is a simple matter of keeping your subject within a certain flash distance range. Your camera manual will tell you what this flash range is for your equipment. An average flash range for many simple cameras is 4 to 9 feet. With many simple and automatic cameras, the shutter "sets itself" for flash when you raise the built-in flash holder or pop on a flashcube.

Exposure with Adjustable Cameras

To make it easy for you to get well-exposed flash pictures with adjustable cameras, film and flashbulb manufacturers print flash guide numbers in film instruction sheets and on flashbulb cartons. These numbers take into account the brightness of the flash, the speed of the film, and the type of reflector. To use a guide number, just divide the guide number by the distance from the flash to the subject. The answer is the f-number to use for that distance.

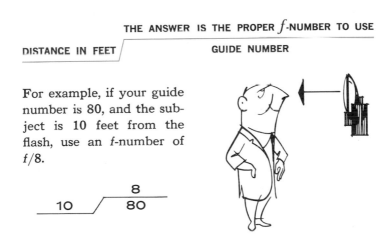

THE ANSWER IS THE PROPER *f*-NUMBER TO USE

DISTANCE IN FEET / GUIDE NUMBER

For example, if your guide number is 80, and the subject is 10 feet from the flash, use an f-number of f/8.

$$10 \overline{\smash{\big)} \dfrac{8}{80}}$$

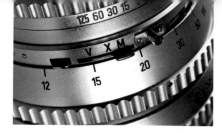

Shutter Speeds and Flash Synchronization: Not all adjustable cameras are intended to make flash pictures at all shutter speeds. With some cameras you should take flash pictures only at a shutter speed of 1/25 or 1/30 second. (Check your camera instruction manual to see if this applies to your camera.) If you try to make flash pictures at higher shutter speeds, you'll get badly underexposed pictures, or no pictures at all.

Some adjustable cameras have flash synchronization settings of "X" and "M." The "X" setting is a "no-delay" setting for use with electronic flash units at any shutter speed or flashbulbs and flashcubes at 1/25 or 1/30 second. The "M" setting delays the opening of the shutter for a fraction of a second to give the flashbulb time to reach peak brightness, and enables you to make flash pictures at shutter speeds up to 1/500 second.

If you're ever in doubt about which synchronization setting to use, use the "X" setting and a shutter speed of 1/25 or 1/30 second. This combination works with any kind of flashbulb, flashcube, or electronic flash.

Flash Batteries

The flash battery provides the power to ignite the flash. A weak or dirty battery can't supply the necessary power. Clean the contacts on the battery and in the camera or flash unit with a cloth dampened with clean water, even if the contacts look clean. (Some dirt deposits are invisible!) When you purchase a battery, make sure that it has been tested properly and that it is the recommended battery for your flash unit.

To Be Sure the Flash Unit Flashes

1. Use the batteries recommended for your equipment.
2. Buy batteries that have been tested and found up to strength.
3. Clean battery contacts and contacts in equipment, even if they look clean. (The deposits on some batteries are invisible.)
4. Insert batteries properly.
5. Tighten any connections between the camera and the flash unit.
6. Oh yes, you can get only one flash out of each flashbulb (four flashes from each flashcube or magicube). Don't forget to change a used flashbulb, flashcube, or magicube.

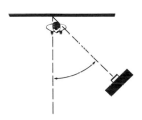

Avoid Flash Reflections

Glass and shiny surfaces will reflect the flash, and you'll get a bright spot in your pictures. You can avoid reflections by standing at a 45-degree angle to shiny surfaces.

The difference between getting an ordinary picture and a good picture may be just one small detail that the photographer overlooks. Have you ever seen a snapshot with a lovely girl in the foreground and a trash can in the background? Trash cans are where you should throw your empty film boxes, but they don't look good in the background of a picture. No matter how nice the girl looks, your eye is distracted by the background. When taking a picture, it's usually easy to change your position slightly to avoid distracting backgrounds.

Certainly, if you continually make well-exposed photographs, some of them will be quite good. The law of averages guarantees this. However, by merely absorbing a few basic ideas about picture-taking, you'll greatly increase your percentage of really good shots.

Certain simple principles exist which can convert what might have been an ordinary snapshot into a really outstanding picture—one that's interesting not only to the person who took it, but to almost anyone. On the next few pages are some ideas which you should try to incorporate into your thinking every time you peer into your viewfinder. They aren't complex ideas, and they don't require the kind of fussing that turns fun into a grim, sober, painstaking business. Once you've consciously experimented with them a bit, you'll find them so normal that they'll be second nature whenever you use your camera.

KNOW YOUR EQUIPMENT

Photographers who know their equipment usually get the pictures they want. People who wait until the last minute to learn how a camera works might easily fumble a picture opportunity. You wouldn't try to drive a car without first finding out how to run it. Become thoroughly familiar with your camera by reading its instruction manual. Then try the various settings on your camera so that you'll remember how to use them. Your

making
ordinary pictures
into
good pictures

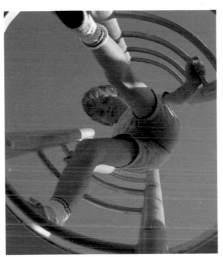

Good background

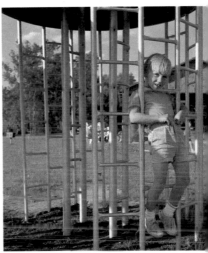

Bad background

good pictures will tell you that you're using the camera correctly.

TAKE YOUR TIME—CHOOSE YOUR BACKGROUND

A plain background can keep the viewer's attention centered on the subject, while a busy background can actually call attention away from the subject. You can almost always find an uncluttered background for your subject if you take your time. Walk around the subject and choose the best point of view.

31

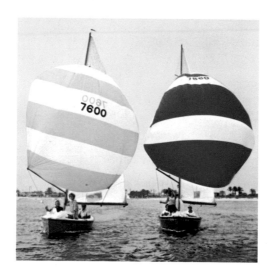

WATCH THE HORIZON

Keep the horizon straight, or the scene will appear to be sliding off the picture. Most pictures are better if the horizon line is slightly higher or lower than the center of interest of the picture.

HAVE THE WHOLE PICTURE IN MIND

After you have composed your picture, and before you snap the shutter, let your eye wander around the edge of the view-finder to check for bright areas and other things that will steal attention from the subject. When you've looked over the whole scene and you're satisfied it's what you want, snap the picture.

HOLD YOUR CAMERA STEADY

One word of advice about snapping the shutter—hold the camera rock-steady and use a steady, squeezing motion to trip the shutter. The biggest picture-spoiler is camera movement—not the obvious kind of movement, but the barely perceptible jiggle when you snap the picture. This type of movement steals the razor edge of sharpness from your pictures.

Hold your camera rock-steady and gently squeeze the shutter release for sharp pictures like this.

Camera movement causes fuzzy pictures that look like this.

Another thing that steals sharpness from your pictures is a dirty camera lens. Clean your lens often with a soft, lintless cloth or a piece of KODAK Lens Cleaning Paper. (Also, be sure that your finger or part of the camera case isn't in front of the lens when you take a picture.)

If you use the hints we've given you in this section, you'll see your pictures begin to improve. Soon, these things will become second nature to you when you compose your pictures.

remember...
- Know your equipment.
- Look around for the best background.
- Include a center of interest.
- Look over the picture for attention-stealers.
- Hold the camera steady.
- Keep your lens clean.

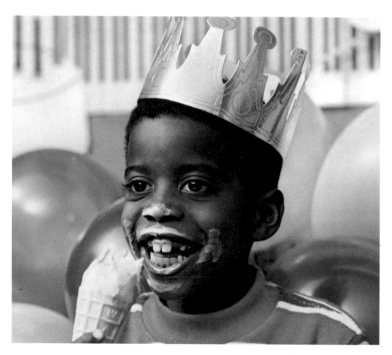

MOVE IN CLOSE

Close-up pictures of people have a lot of impact because you can see so much detail in the subjects. The person is the most important part of the picture, so use your whole picture area to record him. Most fixed-focus cameras will allow you to take pictures as close as 4 or 5 feet. With a focusing camera, you may be able to take pictures as close as 2 or 3 feet. Check your camera manual to see how close *you* can take pictures.

The following sections give ideas and tips for taking pictures of babies, children, and adults. But first, here are some general hints that will help you improve all your pictures of people.

KEEP 'EM BUSY

For the most natural-looking pictures of people—keep 'em busy. People feel more relaxed when they're doing things, and they'll look relaxed and natural in your pictures. If your subject isn't busy doing something at the time, maybe you can find something for him to do—or pretend to do. Even giving a subject a prop to hold and look at can help you capture a natural expression for your picture.

ADD A BIT OF COLOR

Beautiful colors can add so much interest and impact to pictures. Why not *control* the color in your pictures by having your subjects wear colorful clothing whenever possible? Color photography can reproduce beautiful colors, but it can't change a dull gray sweater into a vibrant red. So, if you know you're going to be taking pictures on a family outing, ask the members of your family to wear their brightest clothing.

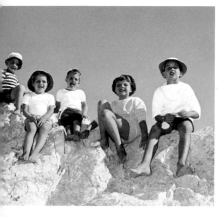

WATCH THE BACKGROUND

Keep your background simple. Use the blue sky for a simple yet colorful background. Foliage or grass also makes a pleasing background when you're outdoors. You can use a plain wall for a background indoors.

FILL-IN FLASH

Take the Squint out of the Picture with Fill-in Flash. People can't help squinting when the sun is glaring into their eyes, and squinting people don't look attractive in pictures. Ask your subject to turn away from the sun, and the squint will disappear. Use fill-in flash, as explained on page 156, to lighten up the shadows.

If you have an automatic or adjustable camera, you can try another method of avoiding squinting eyes. Move people into the shade and watch the squints disappear. Shade produces even, shadowless lighting that is very pleasing in snapshots of people. Try to avoid having a sunlit background when you take pictures in the shade. Bright backgrounds can "fool" automatic cameras.

TAKE PICTURES OF PEOPLE ON OVERCAST DAYS

Don't put your automatic or adjustable camera away when the sun goes behind the clouds. On overcast days shadows disappear, and the lighting is soft and flattering for pictures of people. Try to avoid getting the sky in the picture. The sky is much brighter than subjects on the ground and it can "fool" the meter on an automatic camera into underexposing your pictures.

If your camera or meter indicates that there isn't enough light to take pictures, you should use flash at distances up to 9 feet. Or, if you have an automatic or adjustable camera, you can use a high-speed film, for example, KODAK High Speed EKTACHROME Film (Daylight). Its high speed allows picture-taking in low-light situations.

remember...
- Move in close.
- Keep your subject occupied.
- Use colorful clothing to add interest.
- Keep the background plain.
- Avoid squinting expressions.
- The light in the shade and on overcast days makes pleasing lighting for pictures of people.
- On very dark days, use flash for nearby subjects.

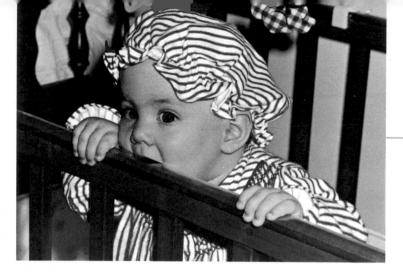

The arrival of a baby is about the most exciting event that can happen in any family. It's hard to visualize that such a tiny bundle of humanity will ever be bigger than he is when you take him home from the hospital. But, babies grow faster than anything imaginable—and before you know it, it's hard to remember that he was ever so very, very tiny. It's hard to recall those hectic, but wonderful, experiences of the baby's first few weeks and months of life—unless you've captured those memories in pictures.

Pictures of babies are easy to take because babies are so expressive—and they ignore cameras. A stuffed animal or a noisy toy can evoke enough cute expressions to fill a baby book or Grandma's album with pictures. Even the baby's daily attempts at learning to get along in the world provide an endless variety of picture opportunities. Keep a loaded camera in a convenient place around your home so you'll be ready to catch impromptu activities, such as the baby's first attempts at crawling, walking, or self-feeding. If you wait to take these pictures, chances are that the chore will have been mastered and you'll have missed photographing important stages in your baby's development. You can't "go back" and get these pictures later. You have to take them as things happen—and many things happen only once. Be sure your camera is one that Mom, as well as Dad, can operate—lots of Baby's activities occur when only Mom is on the scene.

For the first few months, while babies grow very rapidly, take pictures at least once a week. Plan to take pictures every second or third week from six months till the first birthday. This may sound like a lot of picture-taking, and it is, but babies change so much in their first year that it's worth planning a picture-taking schedule to make *sure* you'll get all the pictures you want.

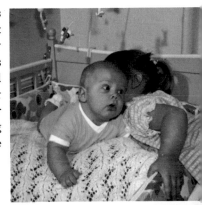

MAKE A PICTURE STORY
OF THE BABY'S ADVENTURES

You can start making pictures of your latest arrival right in the hospital. There's a miraculous newness to every baby, and your hospital pictures will provide a good comparison with later ones.

Some hospital nurseries are lighted brightly enough to permit picture-taking without flash if you have an automatic or adjustable camera with an $f/1.9$ or $f/2.8$ lens. Use KODAK High Speed EKTACHROME Film for color slides or KODAK TRI-X Pan Film for black-and-white prints. Be careful not to include any bright outside windows in your picture. The light from the window will "fool" the meter of an automatic camera and cause anything in front of the window to appear as a silhouette.

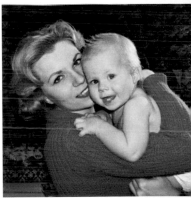

You can avoid disturbing flash reflections from the nursery's window by shooting at an oblique angle to the glass, rather than head on into it.

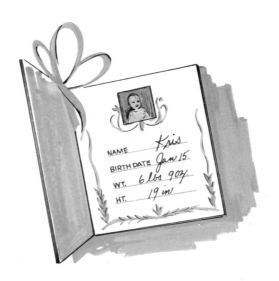

NAME *Kris*
BIRTH DATE *Jan 15*
WT. *6 lbs 9oz.*
HT. *19 in*

Your Baby Book Could Tell a Story Like This:

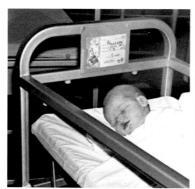

The nurse will usually either hold a newborn up so that you can take pictures or move its bassinet to some convenient location near the nursery window. Move in as close as you can to the window.

Leave the camera at the hospital so that Mom can take pictures.

Feeding Time at the Hospital ...

The Big Day Finally Arrives ... Time to Go Home ...

Mom might want to ask a hospital aid or a roommate to take her picture while she's feeding the baby.

Mom's first chance to dress the baby.

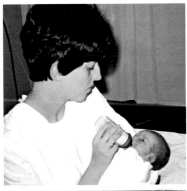

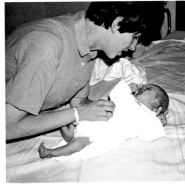

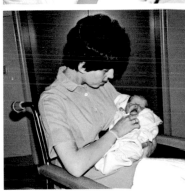

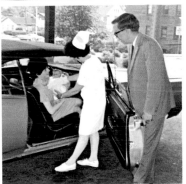

Here they are, all ready to go home.

If you have a friend along, ask him to take a picture for you so that the whole family will be in the scene.

If all this picture-taking during such a busy time sounds like it takes some effort—you're right. It does! But you have to take pictures *during* these activities. You can't decide to do it later— and the pictures are worth the effort.

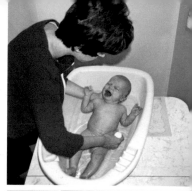

The First Few Weeks

The first few weeks will be filled with lots of "firsts" for the new mom and pop as well as for the baby. No photographic chronicle of babyhood should ignore these activities, so photograph these "firsts": Mom or Dad fixing formula; Grandpa and Grandma holding Baby; and the struggle with the soap, water, and slippery infant—commonly called the first bath. Since the first bath is quite an experience for everyone involved, you'll probably want to snap several pictures to tell the story. You can start with a shot of Mom washing Baby, and then show Baby wrapped in a towel. After a shot of the powdering procedure, finish up with a shot when Baby is dressed.

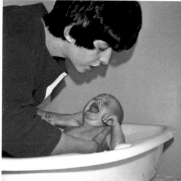

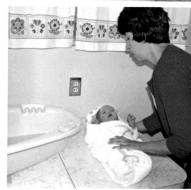

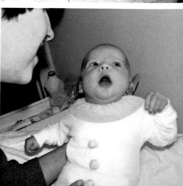

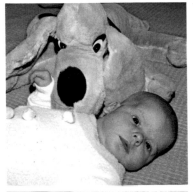

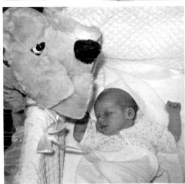

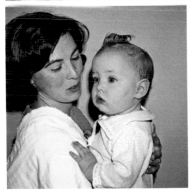

Take pictures of the baby's regular routine. They'll bring back happy memories in the years ahead. For the easiest and best nap-time pictures, roll the crib or bassinet near a window that's flooded with direct sunlight. You'll be able to snap away just as though you were outdoors.

Nearly all baby photos ought to be taken close up, so move in as close as your camera will allow. Your photo dealer has inexpensive close-up lenses that will allow you to take pictures in the 2½- to 4-foot range. If you're using flash for close-up pictures of people, use a flashguard over your flash reflector (flashcubes and magicubes have built-in flashguards), and don't get any closer than four feet from your subject.

Mealtime provides a good opportunity for pictures. After you snap the baby with the bottle, follow it up with an over-the-shoulder shot of the burping routine.

From Three to Six Months

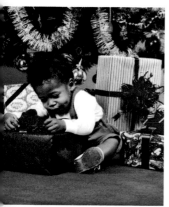

These are the months in which babies become capable of really doing things. Although perhaps not ready to solo in a high chair or baby seat, they manage admirably when propped up by a couple of pillows.

Give a baby a small stuffed toy, a rattle, or a soft blanket, and he will supply all the snapshot material your camera can handle. Whenever you have control over the location of the picture subject, as you do here, choose someplace that provides a plain, uncluttered background. "Busy" backgrounds, with lots of distracting detail, make your picture look disorganized and draw attention away from the subject.

If the baby loses interest in the toy before you've finished taking pictures, have someone provide some entertainment by making noise with a toy, with a coin in a tin can, or with his own vocal chords.

From Six Months Onward—The Age of Discovery

When a baby comes face to face with a dog for the first time, or lays hands on his first lollipop, a single picture of the occasion would be as inadequate as a parasol in a hurricane. Any event that's likely to generate a story demands more than one picture. With a series of pictures you'll capture the whole story, and a series improves the possibility that one of your pictures will turn out to be something extra special. Even professional photographers take several pictures to make sure one is excellent.

44

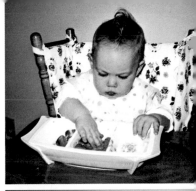

A baby's first attempts at feeding himself can be funnier than any situation comedy that television has to offer. . . . But before you know it, the baby will be feeding himself as though he'd been doing it all his little life. For those funny, heartwarming pictures of the baby putting the food everywhere but in his mouth, shoot pictures during the first few weeks that the baby tries to "do it himself." Try to arrange the high chair where the background won't be distracting, and take pictures during the whole meal. If you're shooting in color, plan to have the baby dressed in colorful clothing. Maybe you can even arrange for colorful food—such as pink pudding.

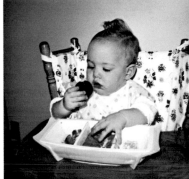

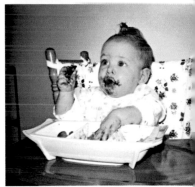

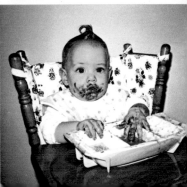

45

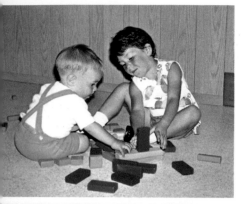

When a baby learns to crawl, he gets really adventuresome and begins to discover all kinds of wonderful things in his ever-expanding world. Sometimes his discoveries can be troublesome, but they're almost always picture material.

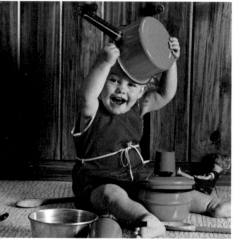

One day, Baby will find the cupboard doors in the kitchen open, and inside there will be all kinds of new toys called pans. You can take pictures while the baby is interested in inspecting each pan. Chances are, she'll be so busy she won't even notice you're there.

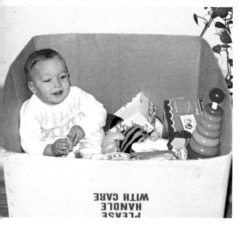

Give a baby a cardboard box or a clothes basket. He will have fun playing with this unusual "toy" that he can climb into and hide under, and you'll be able to snap some unusual pictures.

If you find your "little joy" all tangled up in the toilet tissue or pulling his clothes out of a bottom drawer, take a picture before you interrupt his fun. These everyday events will evoke a chuckle and happy memories when Baby is long past the snooping stage.

With modern, easy-to-use cameras, Mother can be the family historian. Most children's activities take place during the day, while Dad's at work. When Mom keeps the camera handy, she can share all these happenings with Dad when she shows him the pictures.

Any time a baby finds a new friend, whether it's another baby or a small animal, you'll be able to snap good pictures. Keep the camera at a low angle and watch the background.

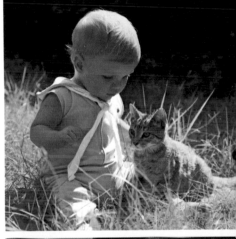

If you want to create some interesting situations for picture-taking, show Baby a mirror. Snap pictures of him discovering himself. Make sure you can't see your own image in the mirror—this is especially important when you're taking flash pictures.

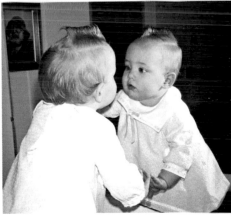

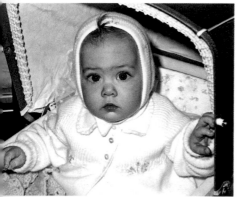

When your baby discovers the great outdoors, be sure you're ready to record each discovery for your album. Take snapshots of Baby "going for a walk" in his buggy or stroller. If the buggy or stroller causes the baby to be shaded, use flash to lighten up the shadows.

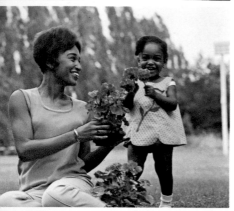

Any time Baby is playing in the yard there will be ample opportunity to snap good pictures. Use the grass or sky for a pleasing background. Catch a baby's expressions as she inspects the flowers, dandelions, and other interesting things in the yard.

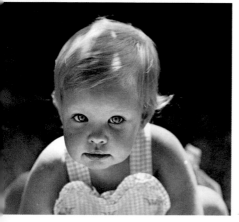

Move in as close as you can with your camera.

One of the biggest events of a boy's first year is that first trip to the barber. This is another time when it really takes several pictures to tell the story. Try to go during the day; there may be enough daylight coming through the window to take pictures without flash if you use KODAK High Speed EKTACHROME Film and an automatic or adjustable camera. If you do use flash, avoid reflections by standing at an angle to mirrors and by making sure that your image doesn't show in the mirror.

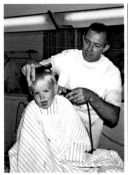 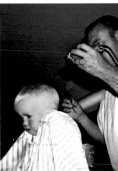 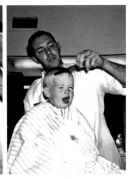

Capture Junior's reactions to this new experience.

Take a close-up as the haircut progresses.

Take pictures from several viewpoints.

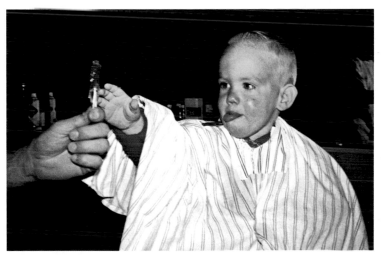

Then finish your picture story with a shot of the finished haircut and the barber rewarding Junior's good behavior with some candy.

When you get out the wading pool so the baby can cool off in the summer, get out your camera, too. Put the baby and some toys into the pool, and the fun will begin.

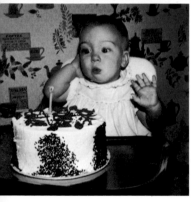

A birthday party provides a natural picture story. Take lots of close-ups. You'll enjoy this first party for years to come if you take lots of snapshots. Aim your camera at the pretty presents before, during, and after Baby discovers them.

The big event that ends a baby's first year is his first birthday. While Baby's all dressed up for this special occasion, snap at least one picture as a record of his growth. For a fascinating series, stand the baby near something big, such as a door frame, a fireplace, or a stairway, and snap his picture. Then every year on the child's birthday, take a picture in the same location.

SHARE YOUR BABY PICTURES

Your family and friends are all interested in seeing pictures of your baby, so share your best snapshots with them. Have enlargements made for framing. You can order extra prints from the negatives for grandparents and friends. You can even have color slides made from color negatives, or color prints made from slides. Your photo dealer will take care of everything.

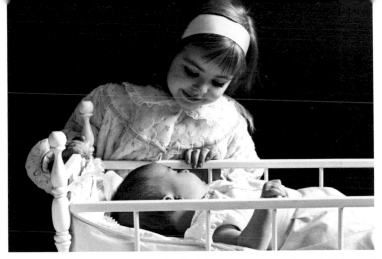

This picture would make a lovely Christmas card, even though it doesn't have a Christmas theme.

One very nice way to use your favorite baby picture is on a Christmas card. A picture for a Christmas card doesn't have to have a Christmas motif. In fact, many pictures on photo-greeting cards are just "good pictures." For more details on photo-greeting cards, refer to page 172.

remember...

- Make a picture story of a new baby's adventures.
- Start taking pictures in the hospital.
- Move in close.
- Keep the background simple.
- Use rattles, stuffed toys, and other props to get a cute expression.
- Take pictures of each new activity a baby tries—self-feeding, crawling, or walking.
- Take pictures of special events—first haircut, first birthday.
- Take pictures of the "everyday" events in a baby's life—playing with building blocks on the floor, playing with other children in the family, discovering things in the yard.
- Share your baby pictures with friends and relatives by ordering extra prints or slides for them.

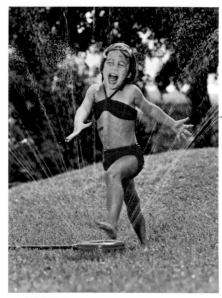

Since children are moving almost all the time, don't ask them to act like statues. Throw any ideas about statues, watching birdies, and saying "cheese" out the window and start anew —take pictures of children **doing** things!

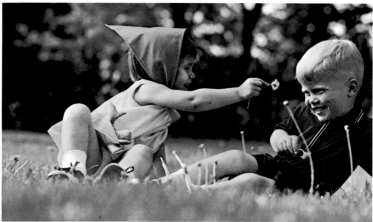

At the quiet time that inevitably comes to even the most frenzied day—the children finally off to bed and the arena of their activities still in disorder—it may be difficult for any pair of exhausted parents to conceive of the growing-up process as anything but an unmixed blessing.

the middle years: ages three to ten

Somehow, though, this all changes as the stages of growing up pass by and leave behind them nothing more of the toddler, the kindergarten scholar, the Space Cadet, the Red Cross nurse, the summer camper, and the intense teen-ager than a scant few souvenirs, a tangle of memory, and some pictures.

But these pictures can be your strongest foothold on yesterday. The kids in photographs never grow up.

Making memorable pictures of growing children is as easy as making pictures of babies. The biggest difference is that the older children move around faster.

In the long run, the photos of your children you'll treasure most are those in which they are engaged in the business of being themselves.

KEEP THEM BUSY

The biggest "secret" of natural-looking pictures of children is to keep them doing something or to catch them doing something. When a child is engaged in an interesting activity, he forgets about the camera and you can capture a natural expression.

HAVE YOUR CAMERA HANDY

The best way to "catch" a child doing something interesting is to keep your camera handy. You may miss a good picture if

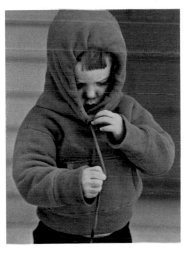

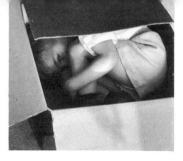

your camera isn't loaded and ready. Children will get used to seeing the camera around, and they won't "freeze" when you start taking pictures. You might hang your camera in a closet or store it behind the breadbox so that it will be handy when you need it.

TAKE PICTURES OF CHILDREN AROUND THE HOUSE

The "everyday" things—children taking a bath, playing in the snow, building castles in the sandbox, or taking a dip in the wading pool—are the things many people may not take because they're not "special." But they're the pictures that show the children as they really are. Be the "family historian" for your family and snap pictures of everyday events. The pictures of events that may not seem special at the time will be *very* special in a few years.

OUTDOORS

On a sunny day at home, a young lady puts on her bathing suit and goes out to play in the pool. A young man gets out the hose and gives the car a "bath." Notice how the backlighting outlines the subjects and adds sparkle to the water. Flash was used to lighten the shadow areas.

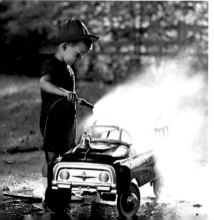
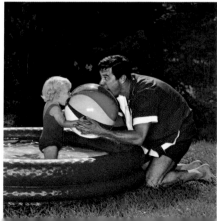

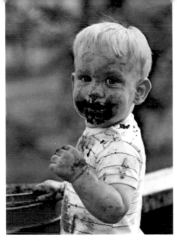

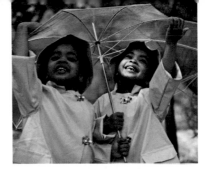

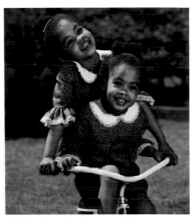

Your first reaction to a boy eating a mud pie may be "What a mess!" If your second reaction is to reach for the camera, you'll get a good picture for your family album.

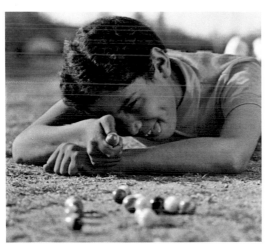

All kinds of "ordinary" events around the house are great picture-taking material. To get good pictures like these, **keep your camera handy and use it.**

Start your picture story dur-
ing the preparations for the
picnic.

Some of the most fun things may happen right in your own
backyard, things like a family cookout. You might want to
make a picture story of your cookout. Taking several pictures
that tell a story of the event helps you to relive that happy time
again and again—in fact each time you look at your slides or
family album.

A typical picture story of a cookout might look like this:

Take a picture showing the
whole family together, and
for the most natural-looking
results, take pictures while
your subjects are doing
something.

Move in for several close-up
pictures because close-ups
show detail and expression.

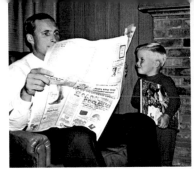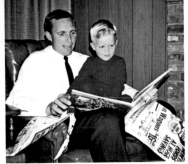

INDOORS

Most indoor pictures are made with flash. Many cameras, such as KODAK INSTAMATIC Cameras, are so easy to use that you just aim and snap—even with flash. Keep your camera handy; a good situation may last for only a few seconds.

During the day there may be enough light indoors to take pictures without flash. If you have an automatic or adjustable camera, you can use KODAK High Speed EKTACHROME Film (Daylight) or KODAK TRI-X Pan Film.

Existing light (the available light indoors) looks natural and pleasing. Focus carefully; there isn't much room for focusing error in low-light situations.

Avoid taking pictures directly toward a bright window. If the light from the window shines directly into the meter of an automatic camera, your subject will be underexposed. Aim from the side of the window.

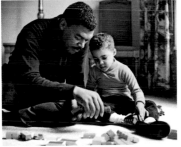

Indoors as well as outdoors, ordinary, everyday activities of children make some of the best pictures. Don't wait for holidays, parties, or special occasions.

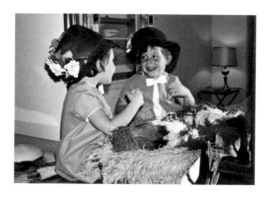

Give a girl a few props and a mirror, and she'll produce all kinds of "snappable" expressions. Always take mirror pictures at an angle to the glass to avoid photographing reflections of yourself or the flash. If you can't see yourself or the flash in the mirror, you should have no problems.

More often than not, children in the house are playing on the floor. Move in close and get down to their level. Ask them to go right on with their activities while you take pictures.

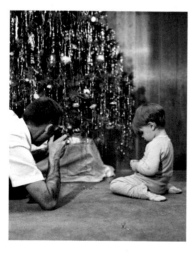

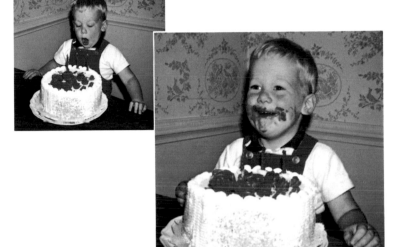

PARTY PICTURES

Parties are always special occasions and deserve good picture coverage. It's often fun to make a complete picture story of the party. You can start by taking pictures when the first guest arrives at the door, and keep on taking pictures until the last guest has departed.

The guest of honor is the center of attention, so move in and take some close-ups of him (or her). You'll really treasure the expression and detail of these close-up shots.

Some walls, even though they don't look shiny, can reflect a lot of glare when you take flash pictures. It's easy to avoid getting the glare in the picture by standing at about a 45-degree angle to shiny surfaces.

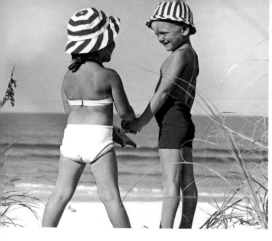
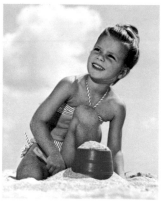

TAKE YOUR CAMERA WITH YOU

To the Beach . . . The sand and surf provide plenty of entertainment to keep children busy while you snap pictures. Keep your camera in its case to keep sand out of the camera.

When you take pictures of children playing in the sand, get down to their level and move in close. A blue sky makes an uncluttered background and adds color to your pictures.

To the Playground . . . Children love playgrounds where they can climb, swing, and hang from bars so high that Mom almost can't bear to watch. Playgrounds provide the opportunity for you to snap pictures of children being themselves. You can shoot through the bars of a jungle gym and use them to "frame" your picture. Try a low angle to emphasize how high the bars and children go.

With automatic or adjustable cameras you can get great shots even on overcast days. Take pictures of children climbing

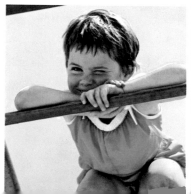
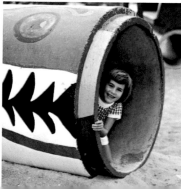

over, under, and through the many unusual "toys" that modern playgrounds feature.

The shutter time on some simple cameras is about 1/60 second. This is a very brief time, but not brief enough to stop action unless you snap the shutter at just the right instant. Catch the action of subjects, such as a child on a fast-moving swing, by snapping the shutter when the action reaches its peak. With simple cameras, shoot the action head on. Any movement at right angles to the camera is hard to "stop" when you can't adjust your shutter speed. If you have an adjustable camera, use a shutter speed of 1/200 or 1/250 second or higher to stop action. Actually, some blurring of the hands or feet shows that the subject was moving rapidly, and may not be objectionable.

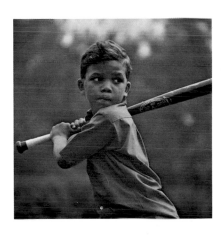

Pictures like this one suggest action even though nothing's moving.

61

Everywhere You Go

Here's proof that even a trip to the neighborhood ice cream stand can provide the subject matter for interesting pictures.

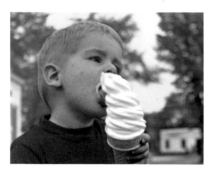

"Boy, do I love ice cream!"

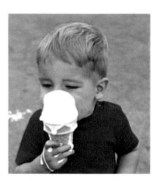

"Things are getting
a little sticky."

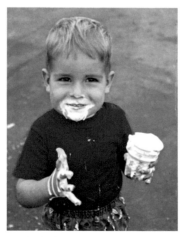

"I **tried** to lick it all around."

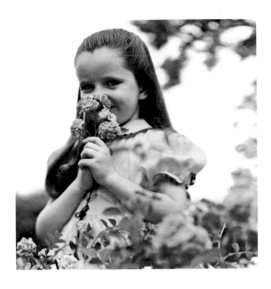

INFORMAL PORTRAITS

You can make memorable informal portraits by using the following two methods to get your young subjects to hold still: props and an assistant.

Props can be very helpful in getting a natural expression. A prop may divert the child's attention from the camera, or it may just give the child something natural to do with his hands. This little girl looks much more relaxed and natural holding the flowers than she would standing like a statue, with her hands at her sides.

Any object that captivates or absorbs a child's interest will help you make pictures showing that special delight or absorption. A few of the most common and successful props for little children are toys, musical instruments, small animals, articles of clothing, books, food, and all kinds of ticking, moving, or flexible gadgets. Sometimes a piece of sticky tape on a young child's finger will keep him amused for a few minutes.

Try to keep your prop out of sight until you're all set up and ready to snap. Then ask someone to hand it to the child. The initial expression often becomes the best picture.

Be ready to make suggestions, such as "Listen to the clock tick," or "Hug your dolly," or "How does it work?"

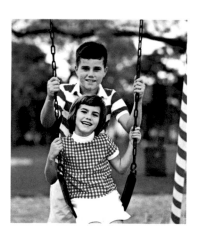

An assistant can be a great help in posing a child for an informal portrait. An assistant can get the child into position and arrange his clothing while you're composing the picture in the viewfinder. When you're ready to shoot, the assistant can talk with the child or hold up a prop to help get a natural expression.

Older children, while easier to direct, are a great deal less easy to divert. Approach them with a camera and there's no disguising what you have in mind. Props, though, are still beneficial—not so much to draw the subject's attention from the camera as to give the subject something to pose with.

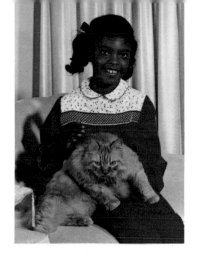

Placing an animal in the hands of an older girl may evoke an entirely different reaction than if you place the same animal in the hands of a three-year-old, but it *will* evoke a response. Chances are, that response will be the best ingredient of your picture.

In pictures children never grow up!

remember...

- Keep your camera handy.
- Take your camera with you to capture pictures of children having fun—at the beach, in the park, at a playground, or anywhere you go.
- Take pictures of children doing things.
- Picture the "everyday" things around the house: children playing puppets, marbles, or dress-up—the things that aren't "special." Such pictures show life as it really is.
- Move in close.
- Get down to the child's level.
- Shoot pictures indoors, with existing light or flash.
- Shoot more than one picture at children's parties for good picture coverage.
- To get natural-looking informal portraits, use props and an assistant.

65

Adults are good picture subjects because they can take directions and are easy to pose. Also, since most adults take pictures themselves, they know that the pictures you take today will provide a pictorial history of their activities. However, some adults try so hard to look "just right" for a picture that they turn out looking stiff and unnatural. If you want to take natural-looking pictures of adults, get them to relax.

People who are occupied are among the best picture subjects.

There was enough light from the window to shoot this picture without flash.

Give your subjects something to do. The easiest way to make anyone forget your camera and relax is to give him something to do. If you interrupted him in some activity, encourage him to continue.

Most people relax more easily sitting than standing. Whether your subject sits on a chair, a floor, the ground, or a flight of steps, chances are that you'll come up with a pleasing snapshot.

If sitting isn't fitting, try leaning. Fences, trees, walls, doorways, and tables are fine "leaning" props. Anything at all contrived to help a subject or group loosen up will pay off in improved pictures.

For bright, sparkling color . . .
take pictures on sunny days.

67

For soft, flattering lighting . . . take pictures in the shade. Use an automatic or adjustable camera. Avoid getting sunlit areas in your background; they can fool the meter of automatic cameras and cause underexposure.

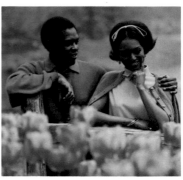

For even lighting and soft colors . . . take pictures on overcast days. Shadows disappear on overcast days and the lighting is good for outdoor portraits. Colors will appear muted, much as they often do in the paintings of the "Old Masters." Keep the sky out of your picture; it is brighter than subjects on the ground, and can fool automatic cameras.

TAKE PICTURES OF ADULTS
ENJOYING THEIR FAVORITE ACTIVITIES

family fun

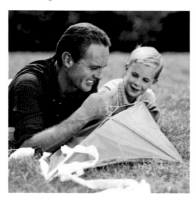

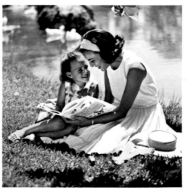

hobbies

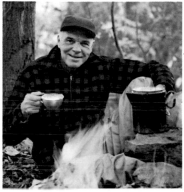

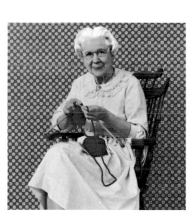

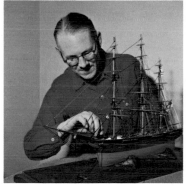

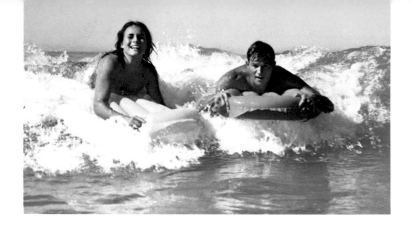

sports

You can snap a rapid sequence of pictures if you have a camera with automatic film advance, such as a KODAK INSTAMATIC 154, 174, 404, 414, 804, 814, or X-90 Camera.

special events

Parties

Parties are for having fun, and people having fun are good picture subjects. Ask the guests to continue their activities while you take pictures. It's easy to avoid the stiffly posed type of picture because you can snap people when they're busy having fun!

Weddings

The yellow pages in the telephone directory contain a list of professional wedding photographers. These photographers are trained to capture the highlights of the occasion, and they produce excellent, professional results. You should depend on the pro for the formal wedding shots, but you may want to supplement his coverage with an informal picture story of the occasion.

Plan Ahead: Make a list of the pictures you especially want to snap. Talk to the bride for ideas. She'll know the shots that the professional photographer will be covering, and you can arrange to take the pictures he doesn't plan to get.

Check with the minister to see if you may take pictures in the church. It isn't appropriate to take pictures during a church service; however, you may be able to take posed pictures after the ceremony. Look over the layout of the church and reception hall to see where you should stand to get the best shots. Pick a position that will allow you to be unobtrusive. Get as close as possible to your subject and use the least distracting background available.

Use a camera-and-film combination that you've used before. Clean your flash contacts and battery contacts. You might want to carry an extra set of fresh batteries along, just in case. Start out with your camera loaded and have your extra film and bulbs readily accessible. You don't want to miss an important shot because you're busy looking for supplies.

How to Go About It: A wedding is a happy, hectic occasion. The people involved will be so busy that they won't have time to be concerned about posing like statues, and you'll be able to snap people in natural poses.

Most of your pictures indoors will be with flash. In a church

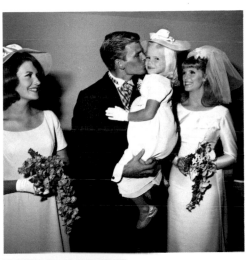

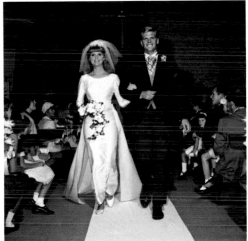

where you don't have nearby walls and a low ceiling to reflect the flash, stick to taking only close-up flash pictures. Watch the background because some walls are shiny and will reflect the flash, causing a bright glare spot in the picture. You can avoid getting a glare spot by standing at a 45-degree angle to wood paneling and other glossy surfaces.

What to Photograph: Here's a sample checklist of the pictures you might want to take (depending on how broad the professional photographer's coverage will be):

A. Before the wedding at the bride's home:

 1 Bride putting on veil—mirror shot
 (Aim at an angle and make sure you can't see the camera or your reflection in the mirror.)
 2 Bride pinning corsage on mother
 3 Bride pinning boutonniere on father
 4 Bridesmaids looking at blue garter on bride's leg
 5 Group leaving for church

B. At the church:

 1 Outside of church
 2 Bride arriving
 3 Groom arriving
 4 Bridesmaids walking down aisle ⎫
 5 Bride and father walking down aisle ⎬ Posed pictures after ceremony
 6 Bride and groom walking down aisle ⎭
 7 Friends greeting couple at back of church
 8 Couple running through rice
 9 Inside car—taken from front seat (use flash) of bride and groom in back seat

C. At the reception:

 1 Bride and groom toasting
 2 Shot of table with cake on it
 3 Cutting cake
 4 Bride and groom feeding cake to each other
 5 Gift table
 6 Couple dancing
 7 Bride throwing bouquet
 8 Groom throwing garter
 9 Couple leaving reception
 10 Decorated car
 11 Bride and groom waving good-bye from car

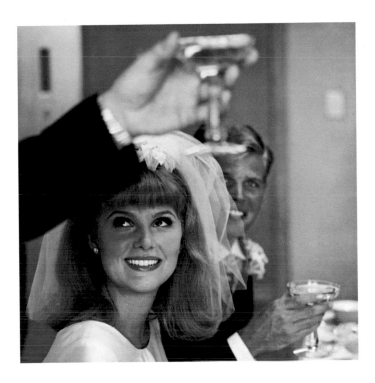

Make sure that the bride and groom have a camera and film to take on their wedding trip. You may want to lend them this book before the wedding so that they can read the "Vacation and Travel" section before their trip.

remember...

- Take pictures of adults engaged in activities.
- People often look more relaxed if they're sitting or leaning.
- Take pictures on sunny days for bright color.
- Overcast days and shady areas are good for portraits.
- Take pictures of people engaged in sports and enjoying their hobbies.
- Take pictures of special events, such as weddings and parties.

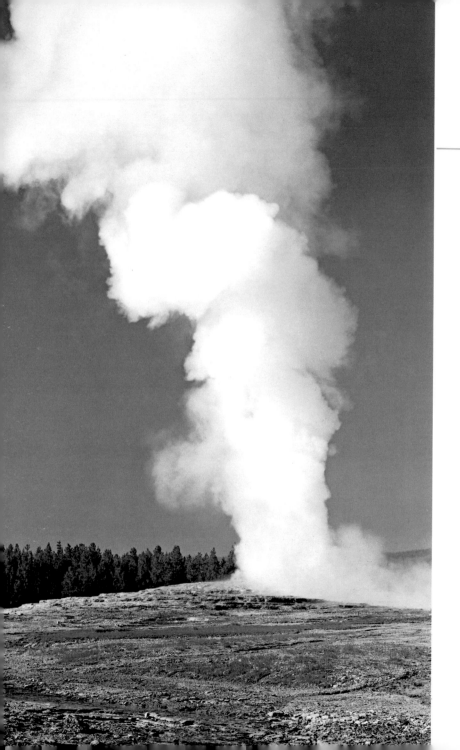

The crowd waits, silent in expectancy. Suddenly, with a subterranean rumble, the first burst of steam and water thrusts from the ground. Its white column rises in fitful jerks until, well over a hundred feet tall, the crest plumes off into the wind.

The people relax now and shout to each other over the hissing. For 5 minutes the geyser spouts continuously and then, its energy spent, the cascade begins gradually to fall and shrink. As it came, it goes. The crowd pauses a moment, then wanders slowly away.

You see all this from beside your projector, or as you browse through your album. For a brief moment, this one part of this one vacation is vividly real again.

PLAN AHEAD!

The weeks and months before your trip or vacation will be filled with thoughts of the exciting places and adventures ahead. You'll be planning your itinerary and all the details of your trip. Take a few minutes to check over your camera equipment. It would be disappointing to discover that your camera wasn't working during your trip. If you have a new camera or one you haven't used for some time, shoot a roll of film and have it processed *before* your trip. See the pictures before you go, to make sure that everything is working properly. If time is pressing, shoot a roll of black-and-white film—it can be processed faster. Have any batteries in your camera and flash unit checked. To be extra safe, clean your battery contacts even if they look clean.

You can get sightseeing and picture-taking ideas from travel folders, commercial travel books, and travel magazines. If you

are really planning ahead, you can write to the Chambers of Commerce in the various cities you'll be visiting. They will send you information about their cities and the surrounding areas. The State Department of Public Information of each state will send you publications about that state's recreational facilities. You can discover interesting places to visit from these folders, and get picture ideas, too. *Kodak Pocket Guide to Good Travel Pictures,* KODAK Publication No. AC-19, is filled with ideas and tips for traveling snapshooters. It's available from your photo dealer.

While you're at your photo dealer's, stock up on film. Although Kodak film is available almost anywhere, you don't want to run out of film and miss a good picture. Also consider taking along prepaid processing mailers. They are very convenient. You put the exposed film into the mailer, attach postage stamps, and mail it to the nearest processing laboratory. The addresses of the various laboratories are printed on the mailer. The pictures will be returned to any address you specify.

Take Your Flash Unit Along

Take your flash unit along so that you can take pictures indoors —such as pictures in your hotel, in monuments, or in museums.

In large rooms with high ceilings, take only close-up flash pictures.

You can use flash to take pictures outdoors at night or on very dark days.

TAKE TITLE PICTURES

If you take plenty of pictures during your travels, they will naturally tell the story of your trip. You might want to borrow a technique the pros use for movies and television: the use of titles. Titles help you organize your pictures and make your travel slides and prints more interesting. Titles show your friends where you've been and help you remember the names and places you might otherwise forget.

Titles on the Road

It's easy to make interesting and effective titles while you're traveling. Almost every place you visit will have some sort of sign identifying it. Add members of your family to the scene—have them look at the sign, not at the camera—and you'll have a ready-made title. Titles help identify the scene and add continuity to your picture story. You'll find all sorts of signs to use for titles that will accent your picture story.

All National Parks and Monuments in America have these built-in title signs just waiting for you to photograph them.

79

The letters for this title were arranged on top of an enlargement of the Lincoln Memorial, then photographed with a close-up lens.

Titles at Home

When you return home and see your pictures, you may find you want some additional titles. You can make these titles at home and add them to your picture story.

These plastic letters are inexpensive, easy to use, and produce professional-looking titles. They're available from your photo dealer or an art-supply store.

You can use a map as a background to indicate your travels, and add small props to make the title more interesting.

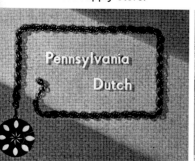

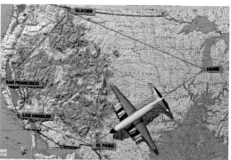

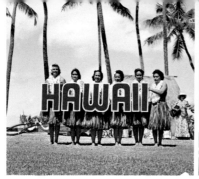

Keep your camera ready for color titles like this one at the Kodak Hula Show in Hawaii.

Title pictures like these are easy to make. Just snap the "ready-made" title. (For taking night pictures, see pages 103 and 104.)

Postcards are colorful and they make convenient titles because the lettering has been done for you.

One of the most convenient ways to make titles at home is with finger paints. You can use the same paint and paper to make many different titles.

The easiest way to photograph titles at home is to work outdoors in the sunlight. Make sure that the light is covering the background paper evenly (unless you want to cast shadows for special effects). Use a close-up lens so that you can fill your whole picture area with the title. Refer to page 131 for details on taking close-ups.

PICTURES WHILE YOU'RE "ON THE GO"

Keep your camera ready for pictures while you're traveling from home to "there" and back again. Pictures made along the way are interesting and they help tell the complete story.

Going by Car?

There's a big advantage to going by car: it permits you to get closer to the country. You can stop at the touch of the brakes to take pictures of any interesting scene. So as you go rolling merrily down the highway in your car, keep your camera on the seat beside you, ready for action.

When the camera's handy, you're more likely to use it to

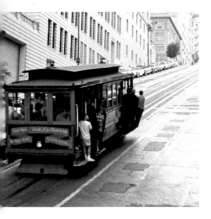

photograph the interesting things you see along the way.

It's always best to stop the car when you want to take pictures, but sometimes it's impossible to stop. If you must shoot from a moving car, shoot through the front window. If you shoot out of the side window, the foreground of your picture will be blurry. If your camera has adjustable shutter speeds, you may be able to "stop" the movement by using a high shutter speed.

Hold your camera as steady as possible without bracing it against the car—the vibration of the car will make your pictures blurry.

If you rent a car, you might want to ask for a bright-colored one. Park it in the foreground of a scene to lend a spot of color and "spice" up your picture!

Film is perishable, just like meat or cheese. Heat and humidity are harmful to film. To protect the good pictures you take, keep the camera on the seat next to you, rather than in a hot place, such as the trunk, glove compartment, or rear-window deck.

You aren't the only one who likes cameras. So do thieves. To avoid tempting some dishonest citizen, it's a good idea to carry your camera with you, or at least not to leave it in plain sight in a parked car.

Going by Air?

If you're going by air, one way to start off your vacation pictures is to ask a friend to snap a picture of you and your family getting on the plane.

If you plan to take pictures from the airplane, try to sit near a window in front or in back of the wing, on the shadow side of the plane. For example, if you're flying from New York to Miami in the morning, try to sit on the right side of the plane, because the sun will be in the east, or on the left. Don't rest the camera against the window—windows vibrate. Also, make sure that the window frame doesn't block out part of your pic-

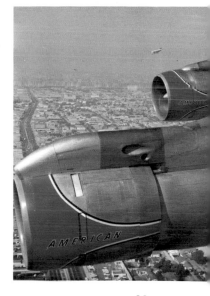

ture. Two good times to shoot pictures are right after takeoff and just before landing. "Pan" to keep the object on the ground centered in the viewfinder. If your camera has adjustable shutter speeds, use a high shutter speed (with correspondingly correct lens opening, of course).

Once you're up in the air, use ½ stop less exposure than that recommended on the film instruction sheet if you can adjust your lens opening manually. Automatic cameras will do this for you. Include part of the plane, such as the tip of the wing, to give a feeling of depth to the scene.

Haze in the atmosphere may cause a bluish cast in color slides made from high altitudes. A skylight filter over your lens will help to reduce the effect of haze. No exposure increase is required with this filter.

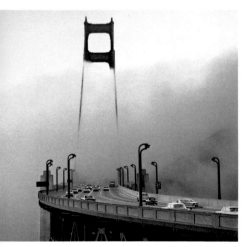

Going by Bus?

You can walk up the aisle, as far as you're permitted, and shoot out of the front window. The side windows are often tinted, and the tint in a window will be visible in your pictures. To get sharp pictures, don't brace your camera against a window.

Going by Train?

Whenever possible, avoid shooting through a tinted window. Keep the subject centered in your viewfinder. If your camera has adjustable shutter speeds, use a high shutter speed. Train windows vibrate, so try to avoid resting your camera against the train window. When you go around a curve, you may be able to include part of the front or rear of the train in your picture to add perspective to the scene. Make sure the window frame isn't in the picture.

Going by Boat?

Shoot some pictures from the rail and then, to add perspective to the scene, step back and include part of the railing, some lifeboats, or some fellow passengers in the foreground.

Watch out for water spray on your camera lens.

Foreground Figures

Notice how the two people in the lower-right foreground emphasize the size of these rocks in Bryce Canyon National Park.

Keep your foreground figures about 25 feet from the camera and have them look into the scene, not at the camera. Brightly clad people add color and interest to scenic pictures.

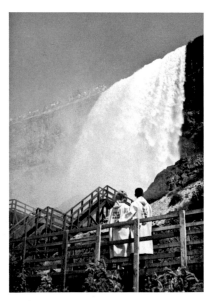

PICTURES OF SCENERY

Nature's wonders are among the most popular of all picture subjects. Fortunately, they're also among the easiest things to photograph well. Oftentimes the difference between ordinary results and good results may be very small. Niagara Falls will never be mistaken for a drippy little 5-foot cataract in any picture, but merely having someone in the foreground will help communicate its size.

Experienced photographers even carry an extra red sweater along, just to be sure that the people in their pictures will be colorful. This kind of planning doesn't take much extra effort, and it could change an ordinary snapshot into an interesting scenic picture.

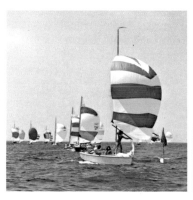 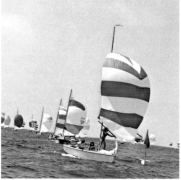

Keep the Horizon Straight

If the horizon is at an angle, your subject will appear to be sliding off the picture. Avoid dividing your picture exactly in half, with the horizon right in the middle of the picture.

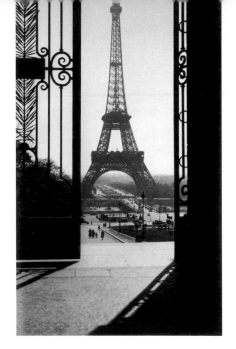

Frame Your Pictures

Almost all the pictures we see hanging on walls have frames around them. The frames are decorative, but they also serve another purpose. They help keep the viewer's attention concentrated on the picture within the frame. You can often "frame" your picture when you take it. The kind of frame we're talking about keeps your attention in the picture and creates a feeling of depth, because the "frame" is an object closer to the camera than the main subject. Keep your frame at least 5 feet from the camera so that the frame and the scene will both be in focus.

Use overhanging branches to frame your scenic shots.

A frame can turn an ordinary snapshot into a picture that reflects the atmosphere of the scene.

What appears to be an uninteresting fence from a normal viewpoint becomes an unusual frame when you use a low angle.

Sometimes, a picture can consist mostly of frame, as this one does.

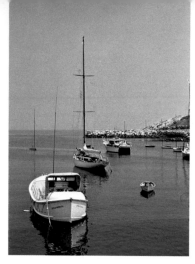

Keep Shooting in Any Weather

Anyone could (and should) shoot this marine scene on a clear day.

But, when the fog rolls in—if you have a camera with an $f/5.6$ or wider lens opening—you can still take pictures and capture a moody scene like the one on the right. Bad-weather pictures offer a change of pace.

Take Pictures Early in the Morning or Late in the Day

When the sun is near the horizon, its light has a warm orange glow and the shadows are long. The pictures you take early or late in the day will capture this "warm" appearance and the dramatic long shadows. These pictures also add a pleasant (and colorful) change of pace to your picture collection.

Dramatic long shadows add interest to your pictures taken late in the day.

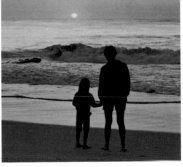

This sunset was taken with an automatic KODAK INSTAMATIC Camera. With any automatic camera, just aim and snap sunsets!

Include something in the foreground of your sunset shots to add interest and create a feeling of depth in the picture.

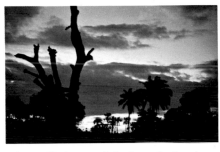

Shoot the Vivid Colors of a Beautiful Sunset

With automatic cameras, wait until the sun is below the horizon or behind a cloud, and then shoot. If you have an adjustable camera, you can try an exposure of 1/125 second at f/8 for films such as KODACHROME-X, KODAK EKTACHROME-X, and KODACOLOR-X Films; and 1/60 at f/8 for KODACHROME II Film (Daylight). These exposures are good starting points, but it's a good idea to bracket your exposures. Make one picture at the recommended exposure, a second picture at one stop less exposure, and a third picture at one stop more exposure—then pick the one you like best.

Keep the scenery beautiful for picture-taking by putting your empty film cartons in a litter basket.

These beautiful stained-glass windows are part of a modern motel. The photographer asked a bellboy to pose near the windows for an interesting silhouette.

TAKE PICTURES AT YOUR HOTEL OR MOTEL

The pictures you take of your hotels or motels will serve as a record of the places you stayed on your trip. The best way you can describe the place where you stayed is in pictures. You might ask someone to snap the picture for you so that *you* can get into the picture.

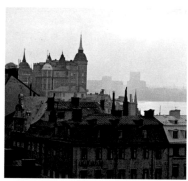

Many hotels overlook interesting views that make great pictures. The views you take from a high hotel window add variety to your vacation pictures.

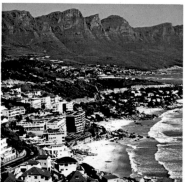

TAKE PICTURES OF LOCAL HANDICRAFTS

Local handicrafts help reveal how some people live and work in different parts of the world. Taking pictures of these handicrafts will help you remember how beautiful they were. You can share the handicrafts with your friends through your pictures. Always ask permission before you shoot. Most people will be happy to cooperate with you. If you promise to send them a picture, be sure to do it. Tell your subjects to keep right on working. When people are busy, they'll relax and forget about the camera.

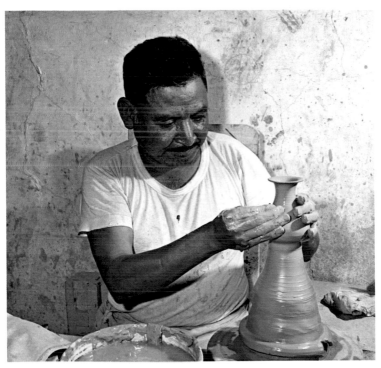

After you shoot overall pictures to establish the locale, move in close and snap pictures of the work. Close-ups reveal many interesting details, such as this Mexican potter's experienced hands shaping the wet clay into a vase.

When the vases are finished, an artist adds the color and design. Move toward your subject until you have eliminated everything except the most interesting part of the picture.

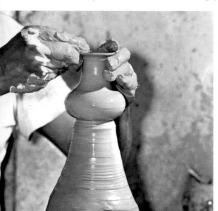 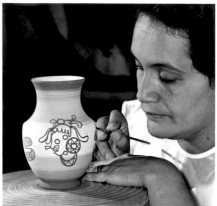

Sometimes daylight goes indoors with you. In buildings with large windows, you can shoot just as you would outdoors with your automatic camera. With an adjustable camera, use a light meter to determine the exposure. The light from the window helps give the subject a natural appearance.

People are usually cooperative and will pose for you if you ask them. Pose your subject in the sun to show bright color and texture, and then MOVE IN CLOSE!

The local marketplace and gift shops offer a wide variety of hand-icraft items. You can take all the Items home—in pictures. You may want to snap one picture to show the overall scene, but for interest-ing details, MOVE IN CLOSE! If you want to fill your whole picture area with a small object, use a close-up lens. See page 131 for de-tails on using close-up lenses.

Get your family in the picture to show that you were there. Take pictures of them shopping in the marketplace or in gift shops.

PICTURES OF UNUSUAL FLOWERS AND FRUITS

You may never have another chance to see the unusual flowers and fruits that grow in faraway places. Chances are, the folks at home have never seen them. Sometimes the only way you can take these perishable things home with you is in pictures.

Flowers such as these yellow water lilies, photographed against their lush green leaves, make striking pictures. The photographer moved in close, and for an added effect, splashed some handfuls of water on the lily pad to make them look fresher.

Colorful fruits, such as these pomegranates, make striking close-ups. A bug just happened to land in the right position to give this picture added interest.

PICTURES OF PEOPLE

During your travels, you'll meet many interesting people you'll want to remember in pictures. People dressed in costumes typical of their country or region make good picture subjects. As we said before, most people will be flattered that you want to take their picture, but be sure to ask permission before you shoot. If you're in a foreign country and don't speak the language, smiling and pointing at the camera will usually get the idea across.

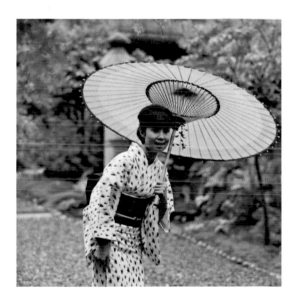

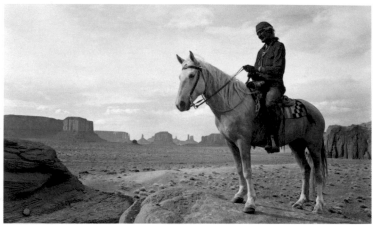

The basket carrier is lost among the other figures in this busy market-place. If you look closely, however, you can see not only the basket carrier but a photographer kneeling in front of him. The photographer is kneeling on the ground so that he can use the sky as a background for his picture, seen above, at right. The photographer eliminated the cluttered background and got this colorful blue-sky background by shooting from a very low camera angle. Keep your backgrounds simple, even at the risk of losing a little dignity.

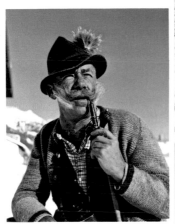

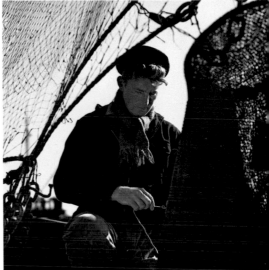

Sometimes you can snap good pictures of people by just being in the right place at the right time. Keep your camera handy so that you can take advantage of unusual opportunities. The photographer just happened to see this little Mexican girl sitting in an interesting pose.

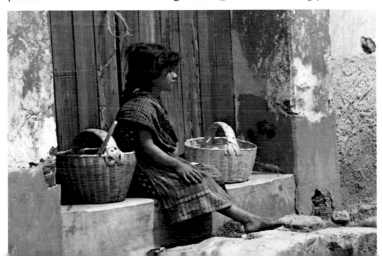

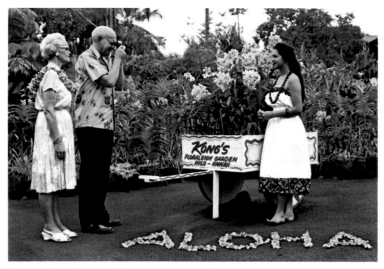

More often than not, however, good pictures of people are arranged; they don't just happen. When you find a nice setting for a picture, don't be shy; ask someone to be your model. Your results will be worth the little extra effort.

Three lovely girls add beauty and charm to this Japanese garden. By giving them something to do, the photographer was able to capture their happy, relaxed expressions.

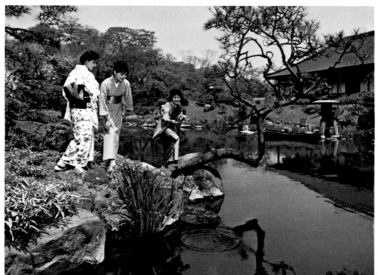

TAKE PICTURES OF MONUMENTS, BUILDINGS, AND FAMOUS PLACES

Taking pictures of the famous places you visit will help you show your friends where you've been. When possible, walk around your subject and snap the picture when it looks the best in your viewfinder.

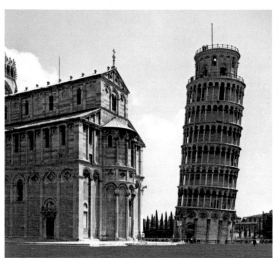

The people in this picture help convey the size of the Leaning Tower of Pisa. You'll probably want to shoot the same subject from several angles.

If you have a camera that takes rectangular pictures, look at the scene with your camera in the vertical and the horizontal positions; then use the viewpoint that looks better.

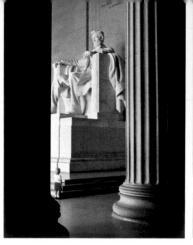 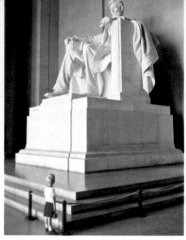

You may want to snap the same subject from different viewpoints and then select the picture (or pictures) you like best to show your friends.

Include people in your pictures of monuments to show the size and emphasize the grandeur of such a large subject. Have the person do something logical, such as looking at the monument, opening a door, or walking up the steps toward a building. A subject that is looking or moving toward your main point of interest will subtly direct the viewer's attention in the same direction.

Watch out for distracting elements that will ruin a well-composed picture. In Taos, New Mexico, the Ranchos de Taos Mission is framed by its own entrance gate. The photographer took advantage of this built-in frame and used a low camera angle to hide the power lines that would have ruined the rustic atmosphere of this scene.

PICTURES AT NIGHT

You'll be proud of the dramatic pictures you can make at night! Photography "after hours" offers special effects you cannot get in daylight. All you need is a camera with an electronic shutter or a "B" (bulb) or "T" (time) setting. Or you can make hand-held exposures if your camera has an $f/2.8$ (or faster) lens. Don't try to use flash. It won't be effective for faraway subjects. If you have an adjustable camera, refer to the table on the next page for recommended exposures for typical night subjects. It's a good idea to bracket your exposures at night—make one picture at the recommended exposure, a second picture at one stop less exposure, and a third picture at one stop more exposure. Use a tripod or other firm support for shutter speeds slower than 1/30 second.

Most cities and towns have at least one floodlit building, monument, church, or university tower. If possible, frame this type of picture with a foreground subject, such as a tree branch.

Floodlit fountains and waterfalls are excellent subjects for night photography.

Suggested Exposures for KODAK Films*

Picture Subjects	KODACHROME II	KODACOLOR-X KODACHROME-X EKTACHROME-X	High Speed EKTACHROME	High Speed EKTACHROME with ESP-1 Processing
Interiors with Bright Fluorescent Light†	1/15 sec f/2 ▲ f/2.8	1/30 sec f/2 ▲ f/2.8	1/30 sec f/2.8 ▲ f/4	1/60 sec f/4
Ice Shows, Circuses, and Stage Shows—For spot-lighted acts only	1/30 sec f/2.8	1/60 sec f/2.8	1/60 sec f/4	1/125 sec f/4 ▲ f/5.6
Brightly Lighted Street Scenes (Wet streets make interesting reflections)	1 sec f/8	1/30 sec f/2	1/30 sec f/2.8	1/60 sec f/2.8 ▲ f/4
Brightly Lighted Night-club or Theatre Districts—Las Vegas or Times Square	1/30 sec f/2	1/30 sec f/2.8	1/30 sec f/4	1/60 sec f/4 ▲ f/5.6
Store Windows at night	1/30 sec f/2	1/30 sec f/2.8	1/30 sec f/4	1/60 sec f/4 ▲ f/5.6
Floodlighted Buildings, Fountains, Monuments	8 sec f/5.6	4 sec f/5.6	1 sec f/4	1/15 sec f/2
Fairs, Amusement Parks at night	1/4 sec f/2.8	1/15 sec f/2	1/30 sec f/2	1/30 sec f/2.8 ▲ f/4
Skyline—10 minutes after sunset	1/30 sec f/2.8	1/30 sec f/4	1/60 sec f/4	1/60 sec f/5.6 ▲ f/8
Niagara Falls at night White lights Light-colored lights Dark-colored lights	30 sec f/5.6 30 sec f/4 1 min f/4	15 sec f/5.6 30 sec f/5.6 30 sec f/4	8 sec f/5.6 15 sec f/5.6 30 sec f/5.6	6 sec f/8 6 sec f/5.6 12 sec f/5.6

*These suggested exposures apply to both daylight-type and tungsten film. When you take pictures under tungsten illumination, they will look more natural if you use tungsten film, while daylight-type film will produce pictures "warmer" or more yellow-red in appearance.

†Tungsten film is not recommended for use with fluorescent light.

Note: The symbol ▲ indicates the lens opening halfway between the two f-numbers shown.

 Use a tripod or other firm support when using shutter speeds slower than 1/25—1/30 second.

A donkey is an indispensable means of transportation in many of the small villages in Mexico.

Donkeys can present transportation problems, too . . . but, problems can sometimes make interesting pictures.

TAKE PICTURES OF UNUSUAL METHODS OF TRANSPORTATION

Add interest and variety to your travel pictures by taking pictures of the unusual methods of transportation you see.

A monorail suspended high in the sky may be a glimpse into the transportation of the future. You can use a polarizing disk over your camera lens to darken blue skies. A dark-blue sky makes a dramatic background for pictures. A polarizing disk can be used only on an adjustable camera or an automatic camera with a through-the-lens exposure meter, however, because it requires approximately two stops more than the normal exposure.

Whenever you shoot indoors without flash, take extra care to hold your camera steady. Camera movement is more noticeable at the slow shutter speeds you'll be using under these lighting conditions.

Move in as close as possible to fill your picture area with the subject. If you use flash for displays that are behind glass, stand at an angle to the glass to avoid reflections.

TAKE YOUR CAMERA INSIDE MUSEUMS AND CATHEDRALS

The interesting and unusual shots you can make inside museums and cathedrals will add color and variety to your travel pictures. Museums and cathedrals contain many priceless objects of art and history that may not be in existence anywhere else in the world. You may be able to capture these unusual things in pictures. Be sure to check to see if picture-taking is permitted. Some places allow all kinds of picture-taking and some permit it only if you do not use flash or a tripod.

If you have a nonadjustable camera, flash is necessary for pictures indoors. Some modern museums are so well lighted that you can snap pictures without flash if you have an adjustable camera. Due to the great variations in lighting, an exposure meter is very helpful. If you don't have a meter, try 1/30 second at $f/4$ with KODAK High Speed EKTACHROME Film. In tungsten light, use High Speed EKTACHROME Film (Tungsten).* Use High Speed EKTACHROME Film (Daylight) if most of the light is from windows or skylights, or if fluorescent lighting is predominant.

*See footnote on page 10.

Museums all over the world have interesting, carefully arranged dioramas for you to photograph. The opossum is in Washington's Smithsonian Institution, where a mixture of tungsten and fluorescent lighting allows you to snap pictures on daylight-type films without flash. With fluorescent lights alone, the color would appear slightly greenish.

This huge 200-inch telescope mirror is on display at the Corning Glass Center in Corning, New York. The figure in the foreground adds interest and size comparison.

The Henry Ford Museum in Dearborn, Michigan, features a large collection of historic trains, cars, and planes. The boy adds a spot of color and provides size comparison.

This church in Santa Domingo was started in the sixteenth century and completed in the seventeenth century. The years of work that it took to complete it are reflected in the beautiful detail of the interior of the church.

Many churches have beautiful stained-glass windows, which are surprisingly easy to photograph. Don't use flash. It ruins the translucent appearance of the window, and you might end up with bad reflections. Shoot from as close as possible so that the window fills your whole picture area. Anything in front of the window will be silhouetted. If you don't have an exposure meter, try an exposure of 1/60 second at f/4 with KODAK High Speed EKTACHROME Film.

This is one of the many intricate stained-glass windows in the Franciscan Monastery in Washington, D.C.

The sun filtering through stained-glass windows in the United States Air Force Academy Chapel, outside Colorado Springs, produces this colorful pattern. You can shoot it at 1/60 second at f/4 on KODAK High Speed EKTACHROME Film (Daylight).

IF YOU GO ABROAD

Customs Regulations and Cameras

Not much of a problem here: A tourist without a camera is as rare as a tourist without a toothbrush. As a general rule, an amateur camera or small gadget bag goes back and forth across international borders without any difficulty, and in most instances without even being weighed by airlines.

If you're a real camera "bug" and have several cameras (especially those of foreign make), it's a good idea to register them at any customs house before you leave the United States. This registration takes only a few minutes, and the form is readily available at any port or international airport. A customs inspector will help you.

Is Film Available Abroad?

Yes—but take enough film along so that you won't run out if you find that the film you want isn't available. Although the more popular sizes and types of Kodak film are generally available throughout the free world, import restrictions or unusual demand may cause a shortage of a particular kind at a particular spot. Film prices abroad may differ from those you pay in the United States. Duty and local taxes vary from place to place. You can safely plan to buy film en route in most areas, but keep a few rolls of your "from home" film in reserve.

How Much Film?

There is no definite answer, of course. It all depends on the duration of your trip, on whether you are "on your own" or on a tour, and on how sharp your eyes are in seeing things to photograph. How does enough film to take 20 to 24 pictures a day sound to you? You shouldn't encounter any customs problems on this basis.

It's always best to have your film processed as soon as possible after exposure. For brief trips of 2 or 3 weeks, simply carry the exposed film with you and have it processed when you return home. For longer trips, you may want to send the film to a laboratory for processing while you're still traveling. Mail it yourself—hotel employees may forget. Processing of KODACOLOR-X and KODAK EKTACHROME Films is widely available throughout the world. Consult a local photo dealer for information. Processing of black-and-white films is available almost everywhere. Where local service is rapid and your schedule permits, have an occasional roll returned for your inspection so that you can see how you're doing. Or, have a processed roll returned to a friend at home so that he can advise you.

The purchase price of KODACHROME Films sold outside the United States usually includes the cost of processing by Kodak. This film will be processed without further charge by any Kodak Laboratory anywhere. KODACHROME Films are sold in the United States without the cost of processing by Kodak being included in the purchase price.

Whenever you buy KODACHROME Films abroad, look carefully at the film carton, which always states clearly whether or not processing by Kodak is included in the purchase price. Sometimes, people think that the mailing bag, packed with the KODACHROME Film whose price includes processing, can be used to get "free" processing for domestic KODACHROME Film sold without the cost of processing included. But it doesn't work out that way. The mailing bag represents no processing value (except in the case of KODAK Prepaid Processing Mailers). The *film itself* is edge-marked so that the processing laboratory can tell whether it was sold with processing included. A non-Kodak laboratory will charge for processing all film, whether or not a charge for processing by Kodak was included in the film price.

- Check over your equipment before you leave.
- Take enough film.
- Take your flash unit.
- Make picture stories by taking more than one shot of an activity.
- Make title pictures.
- Take pictures while you're on the go—from airplanes, trains, cars, buses, or boats.
- Take pictures of:

remember...

scenery	people dressed in colorful costumes
your hotel or motel	
the view from the window of your room	famous places—buildings and monuments
local handicrafts	unusual transportation
unusual flowers and fruits	objects of art and history in museums and galleries

- Include people in your pictures.
- Take pictures early and late in the day and in any kind of weather for variety.
- Take long shots and close-ups.
- When you go abroad, one camera will go through customs easily—with more than one camera, better register with customs.
- Have your film processed as soon as possible.

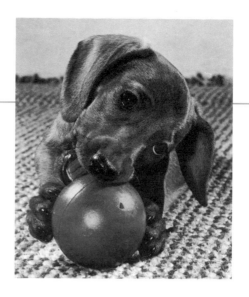

In his book One Man's Meat, *E. B. White wrote: "Being the owner of dachshunds, to me a book on dog training becomes a volume of inspired humor. Every sentence is a riot. Some day, if I ever get a chance, I shall write a book or warning on the character and temperament of the dachshund and why he can't be trained and shouldn't be . . . When I address Fred I never have to raise either my voice or my hopes. He even disobeys me when I instruct him in something that he wants to do. And when I answer his peremptory scratch at the door and hold the door open for him to walk through, he stops in the middle and lights a cigarette, just to hold me up."*

What is distressingly true of dachshunds is equally inevitable among the entire legion of species we have invited across our doorsteps and hopefully labelled "domesticated." At no time is the general contrariness of these beasts as evident as when you want to snap some pictures of them. People who can endure long, damp hours in duck blinds without a murmur of protest find their patience torn asunder by a balky beagle.

The simple truth is that the only animal really easy to photograph is a sleeping animal, and even one of these may hold some surprises.

pets
and other animals

But dogs, cats, birds, and other animals can be the most appealing photographic subjects in or out of captivity. The magic catalyst for getting good pictures of animals is patience.

TRICKS OF THE TRADE

Props are of enormous assistance when you take pictures of animals. Tempt a dog with a rubber bone he particularly favors (one you've taped to the floor with transparent tape) or with a dish of milk. You can be reasonably certain, at least for a moment, that you'll be snapping an animal and not the place where an animal happened to be a few seconds ago.

 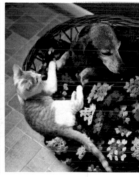

There are a few "tricks" you can use to get the animal's attention. Shake a penny or marble in a small can (like a 35mm film can) or crinkle the cellophane from a cigarette package. Try making animal or other unusual sounds. Tempt your subject with his favorite treat. Greasy foods will cause the animal to lick his lips.

You may want to enlist the aid of an assistant to entertain the animal with a toy or a piece of paper tied to a string.

113

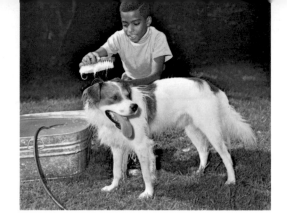

Before you even bring the animal into the picture-taking area, have your camera loaded and be ready to shoot. Select an uncluttered background for your animal pictures. You want to center attention on the subject, not on a busy background.

If you really want to snap some prizewinning animal pictures, try putting two unlike creatures together, such as a cat and a dog, a cat or dog and a stuffed animal, an animal and a child. You can shoot pictures of them inspecting each other. Sound difficult? We agree that it could be, but if you really want to capture an interesting animal picture, it will be worth the effort.

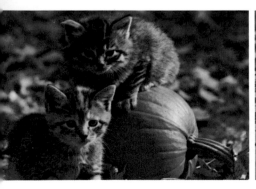

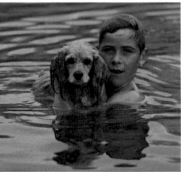

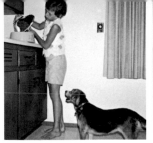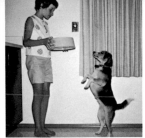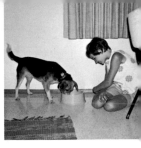

DOGS

When there's a dog in the house, he's the personal pet of every member of the family. People like to take their dogs with them when they travel. Unfortunately that's not always possible, but you can take pictures of your dog along to show your friends. One of the reasons dogs make such good family pets is that they do so many cute and lovable things . . . things you'll want to remember in pictures.

Take pictures of your dog doing things with your family. These pictures of the "everyday" things, such as the dog waiting for his dinner or romping with the kids, show your dog as he really is . . . almost a member of the family.

When you take pictures of your dog alone, move in as close as possible and fill the picture area with your subject.

If your dog is very active, you may find that one of the best times to take pictures of him is just before or after a nap.

115

CATS

Cats are lovable, soft, furry fellows who often like nothing better than to curl up in a convenient lap to have their backs stroked. Cats can really win your heart, and they can be great picture subjects.

Almost all of the suggestions for shooting pictures of dogs will work for pictures of cats, too. You can keep a cat in the shooting area by taking pictures of the cat doing things with your family. Pictures of the cat engaged in a family activity are pictures you'll always treasure.

Indoors, most of your pictures will be made with flash. Just as in portraits of people, however, you can sometimes get a nice picture by using only the light from a nearby window. Be sure that it's a sunny day and that you have an automatic camera or an exposure meter to tell you if there's enough light for a good picture.

Cats often love to sit in windows. If yours doesn't, try moving his bed into a sunny spot near a window; then take pictures while he's asleep.

For a really unusual picture of your cat, sit down for a while and wait until the cat wakes up. If he's anything like the cats

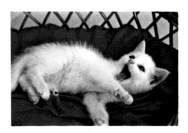

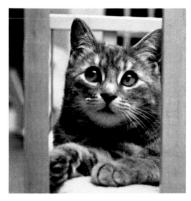

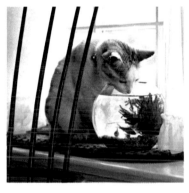

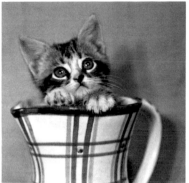

If you want to "catch" the cat in a good pose, you'll have to be a sleuth and "follow that cat." The daylight from the window provided the light for the shot on the left. (P.S. The fish were saved.)

we've observed, he'll give you a very expressive yawn. He may even step out of his bed and take a long, long stretch. When his back and tail are arched and his mouth is open in a huge yawn, snap your picture. We think you'll find the results were worth waiting for.

One good way to keep cats in one place is to put them in something. Kittens love to curl up in hats, knitting bags, or small boxes. They'll be content to make themselves comfortable while you snap pictures.

117

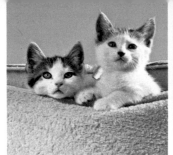

When the background is pleasing, get right down to the cat's level and shoot from there. If the background is distracting, shoot from a high angle and use the grass or floor for a background. If your cat doesn't object to high places, try putting him on a fence, or wall; then you can crouch down and use the blue sky for your background.

FISH

Pictures of fish make colorful and unusual additions to your slides or photo album. Fish are small, slippery characters, so you'll need lots of patience to catch good pictures of them. Use a close-up lens so that you can move in extra close to the fish tank. Refer to page 131 for more information on close-ups.

The lights on most fish tanks aren't bright enough for picture-taking purposes, so use flash. When you use flash at close distances, cover the flash reflector with a handkerchief to cut down the light; see page 136. Shoot at a 45-degree angle to the front of the fish tank to avoid reflections from the glass.

If you're really an avid fish fancier, and you want to get a little more involved when you photograph your fish, you might want to try the method used to make the pictures of fish shown on these pages. You will need a reflector photolamp and a light

socket in addition to your camera and close-up lens. A reflector photolamp isn't very expensive and will fit in the regular socket of a desk or pole lamp. (This kind of light does get hot, so avoid putting one in a lamp with a plastic shade.)

Position the lamp over the fish tank and aim it at the bottom of the tank as illustrated. With the light in this position, you'll get even, natural-looking lighting in the tank.

Although the light is bright, you'll also need to use a "fast" film, such as KODAK High Speed EKTACHROME Film (Tungsten). If you can't get the Tungsten film for your camera, you can use KODAK High Speed EKTACHROME Film (Daylight). However, the pictures you take on the Daylight film will have a warm, yellow-orange cast.

You can hold a cat or dog in position for pictures, but you can't hold a fish (well, not without getting wet). However, you can wait until the fish swims close to the glass and "catch" him in a close-up. Pull up a chair, compose your picture, and wait...

when the fish swims in close to the front of the tank, snap your picture. Some avid photographers of fish have a piece of glass cut to fit their tanks. They put the glass sheet in the tank to force the fish to swim in a small area between the glass and the front of the tank. Confining the fish to a small area makes it easier to "catch" him in a close-up. Your patience will be rewarded when you see your unusual pictures.

BIRDS

Move the birdcage to a window on a bright day and take pictures, using the daylight coming through the window. Stand with your side toward the window while you shoot. If you aim an automatic camera toward the window, the bird will be a silhouette. In good weather, you may be able to move the cage outdoors. If your bird is trained, you may want to take him out of the cage to avoid getting the bars in the picture.

This picture was shot with a KODAK INSTAMATIC 804 Camera focused on 3 feet.

This picture was made with the same camera. By using a 3+ close-up lens, the photographer was able to move in close.

Refer to page 131 for details on using close-up lenses.

On dull days, or if the low-light warning shows in an automatic camera, use flash. Put one layer of handkerchief over the flash reflector for close shooting. You can move in extra close by using a close-up lens.

AT THE ZOO

In the many zoos around the country you can see animals from all over the world. These animals can bring to mind visions of far-off places. A child might imagine himself a brave lion hunter deep in Africa. The young hunter slips as close as he can to get a better view of the king of the beasts. The king rises, slowly stretches, and then lets out a mighty roar . . . and the young hunter retreats to a safe spot behind his mom or dad.

All you really need for a trip around the world at the zoo is a little imagination and some sturdy walking shoes. You might first see the polar bears from the frigid, northern parts of the world and a few minutes later see an alligator from the jungles of the southern parts.

You can take any of these animals home with you . . . in pictures. Not many people would want a lion as a house pet. But, show a child a picture of that lion he "hunted down" at the zoo, and he can recall his whole adventure.

A photographer has an advantage at the zoo—the animals are contained in a definite area. All you have to do is have enough patience to wait until the animal comes your way, or does something worth snapping. Although waiting seems like a lot of trouble, it may be the only way to get a good animal picture.

More and more modern zoos have eliminated bars. You can shoot pictures in any part of the animals' area without concern about bars getting in the way.

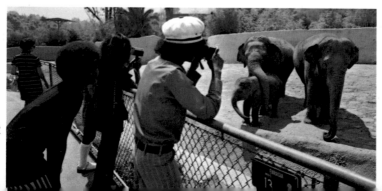

However, if you are separated from an animal by bars, move in as close as possible and aim through the bars. If there is no way to avoid the bars, try to aim so that the bars don't cover the animal's face.

remember...

- Use props to keep pets in the shooting area.
- Ask someone to help you get a pet's attention.
- Be ready to shoot before you bring your pet into the picture-taking area.
- Keep the background simple.
- Put two animals together and take pictures of them inspecting each other; also, snap pets with people.
- Take pictures of pets doing things with your family.
- Follow pets to catch them in a good pose.
- Use a close-up lens and flash to photograph fish.
- Wait until a fish swims to the front of the tank.
- Take pictures of birds in daylight by moving their cage near a window or outdoors.
- Patience pays off at the zoo; sooner or later an animal will do something worth snapping.
- Shoot between the bars or aim the camera so that the bars won't cover the animal's face.

Winged skis singing down a powdered slope or silver spray flying from a speeding hull—sports mean action, color, excitement, fun, and adventures for your camera.

Some people enjoy their favorite sport from the bleachers. Others choose a sailboat, a golf fairway, a fishing stream, a bowling alley, or a sports car. No matter what sports you enjoy, combining them with photography makes a happy marriage.

There are hundreds of different sports, from archery to water-skiing. Each has its own photographic rewards and problems. We'd like to lump together some general categories of sports photography and give some bits of advice you may find helpful.

It's easy to record any sport in pictures. People look natural when they're involved in sports activities, not stiff and posed. Pictures of you enjoying your favorite sport may actually help you improve your form.

All sports involve action, and photographing action requires certain techniques.

SIMPLE AND AUTOMATIC CAMERAS
(Without Shutter-Speed Adjustments)

There are four ways to capture action with these cameras:

1 Station yourself so that the action will come directly toward you. This minimizes the effect of the motion and will often allow you to shoot a good picture of a subject that would look like a featureless blob in a picture made from a side angle.

124

2 Snap the picture during the split second of suspended action. The final instant of the top of a golfer's backswing, the highest point in a skier's jump, the child's swing just before he starts to go in the other direction—these are all moments during which there is little motion.

3 For shooting certain moving subjects (things like cars, boats, and planes), center the subject in your viewfinder; then move the camera so that the subject stays centered in the finder. This technique is called "panning." Whenever you wish, just snap. The picture will show the subject sharp while the background is blurred, due to the camera motion. This blurring will not be objectionable, since the background is probably of little importance and the blurring emphasizes the feeling of speed.

4 The farther a subject is from the camera, the less apparent any movement will be. Avoid tight close-ups if you can't use one of the action-stopping techniques mentioned above.

AUTOMATIC AND ADJUSTABLE CAMERAS
(With Shutter-Speed Adjustments)

Follow the four rules given for cameras without shutter-speed adjustments, but add a fifth rule: Use a high shutter speed. A fast speed like 1/250 or 1/500 second will stop almost any sports action.

FORMAL SPORTS ACTIVITIES

You can get some fine pictures of major sporting events from up in the stands, and capture much of the atmosphere and excitement of the occasion at the same time. For instance, at a big football game you can photograph the band formations, any card stunts, and the brightly uniformed teams lined up for scrimmage. But a grandstand seat almost always places you too far away from the action to take the kind of pictures that make the pages of newspapers and magazines. At these events, an amateur photographer just can't work his way down to the arena where the press photographers operate. Promoters of these events dislike people who try to pass themselves off as professional photographers, and anyone who tries it risks an abrupt bum's rush. So, stay in your seat and look for the many exciting, colorful pictures you can take from there.

Football or Baseball at Night

In a stadium that's really well lighted, you can make pictures at night with high-speed films if you have an automatic or adjustable camera with an $f/2.8$ lens. Although illumination will vary from one stadium to another, a good starting point with KODAK High Speed EKTACHROME Film (Tungsten) would be $1/60$ second at $f/2.8$. For black-and-white pictures, use KODAK TRI-X Pan Film and a setting of $1/60$ second at $f/4$.

Some higher-priced adjustable cameras have interchangeable telephoto lenses which allow you to take pictures that look like close-ups, even though you and the camera were actually far away from the subject.

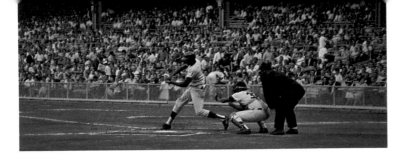

Basketball

Many basketball courts have enough light for you to take pictures without flash if you have an automatic or adjustable camera. Use KODAK High Speed EKTACHROME Film (Tungsten) for color slides, or KODAK TRI-X Pan Film for black-and-white prints. With non-automatic cameras, use a meter to determine your exposure. If you use a slow shutter speed, pan with the action or take pictures when the players aren't moving fast.

Flash isn't very useful at night sports events, because the players are almost always too far away for flash pictures.

Wrestling and Boxing

You can make exciting and colorful pictures without flash at wrestling and boxing matches. Try 1/60 second at f/2.8 with KODAK High Speed EKTACHROME Film (Tungsten).

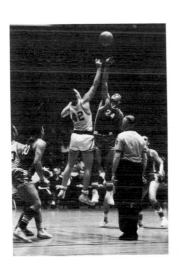

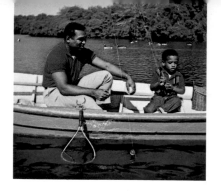

Swimming, Boating, Fishing, and Other Water Sports

Move in close to your subject—be careful not to fall into the drink. If you're on the shore, try to include a tree branch in the foreground to give the scene a feeling of depth.

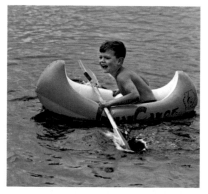

Snap rapidly moving boats or water-skiers when they are moving toward you, or pan with the action so that you can "stop" the motion. If you're riding in a boat, be careful not to brace your camera against the boat. Its vibrations will cause camera movement. Watch out for water spray on your camera lens.

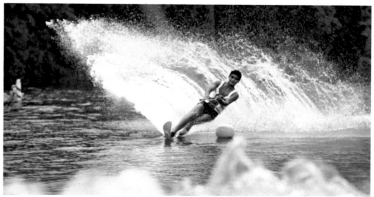

Take your camera with you to capture the fun you enjoy in sports.

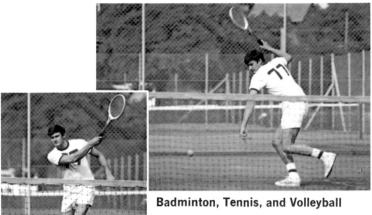

Badminton, Tennis, and Volleyball

Take one shot of the whole court to establish the scene; then snap the players in action. If your camera doesn't have fast shutter speeds, wait for the top of the backswing in tennis and badminton; then snap.

As these pictures show, it's often hard to get an uncluttered background. You may be able to use a low angle and photograph your subject against a blue sky.

remember...

- There are four techniques that make it possible to take action pictures even with a simple camera:
 1. Take pictures when the action is coming toward you.
 2. Shoot during "suspended" action.
 3. Pan with the movement of the subject.
 4. Avoid tight close-ups.
- With an adjustable camera, you can also use a high shutter speed to stop action.
- Take pictures from the grandstand at formal sporting events.
- Use a high-speed film in an adjustable camera to take pictures of sporting events at night or indoors; flash is usually of no use under these conditions.
- When you take pictures from a boat, don't brace the camera against the boat, and watch out for water spray on the lens.

Hobbies are fun. They give us relaxing things to do in our leisure time. Your hobby may be anything from collecting mushrooms to assembling cars. But whatever your hobby, you can enjoy it more if you combine it with photography. Pictures let you share your hobby with others.

A rare blossom lives for only a few days in your garden, but it can live forever when you capture its beauty in a picture.

If you're interested in large things, such as antique cars, you may not be able to "collect" every car you admire, but you can collect pictures of every car. You can carry your whole collection of pictures right in your pocket and share them with other antique-car lovers whenever and wherever you desire. Perhaps you go in for collecting more delicate things, such as china cups. Here, again, pictures are a very convenient way of displaying your collection, and you don't run the risk of breaking one of your valuable collectors' items. Pictures provide a good way of showing bulky, fragile, or very valuable things when you can't show the originals.

130

CLOSE-UPS

Many hobbies include small objects—such as miniature cars, model trains, stamps, or the prized blossoms of your garden. You can show all the intricate beauty and detail of these tiny objects in close-up pictures.

With most fixed-focus cameras, you can take sharp pictures as close as 4 or 5 feet, and adjustable cameras often focus as close as 2 or 3 feet. This is close enough for big objects such as a large model train or a giant dahlia bloom, but for most small objects, you'll want to move in much closer.

You can move in closer than the camera's minimum focusing distance by putting an inexpensive close-up lens over the camera lens—just like a filter. Your photo dealer will help you select what you need to fit a close-up lens on your camera.

The strength of a close-up lens is indicated by its number, such as 1+, 2+, or 3+. The bigger the number, the closer you can get to the subject. It's also possible to use two close-up lenses together to get even closer to your subject than you could with either lens alone. For example, you could use a 2+ and a 3+ lens together. This combination would let you get as close as a 5+ close-up lens. The stronger close-up lens goes next to the camera lens.

FOCUSING WITH CLOSE-UP LENSES

Each close-up lens will focus sharply only within a limited range of a few inches. To get sharp pictures, and to simplify focusing, it's best to use lens openings between $f/8$ and $f/22$. With automatic cameras, this means shooting in bright light or using flash.

131

Here's a table of the most popular close-up lenses, showing their focusing ranges. The instructions accompanying each lens will give you the exact focusing distance for use with your camera.

CLOSE-UP LENS	CLOSE-UP LENS FOCUSING RANGE (in inches)
1+	20⅜ to 38¾
2+	13⅜ to 19½
3+	10 to 13
4+ (3+ and 1+)	8 to 9⅞
5+ (3+ and 2+)	6½ to 7⅞
6+ (3+ and 3+)	5⅝ to 6½
8+	4⅝ to 5⅛
10+	4 to 4¼

This picture shows the narrow range of sharpness you get with a close-up lens. The flower is in sharp focus, but the stem is fuzzy. Focusing is critical, so it's best to **measure** the distance from the front of the close-up lens to your subject. The instructions with the close-up lens will tell you how close you can get and how much area your picture will include.

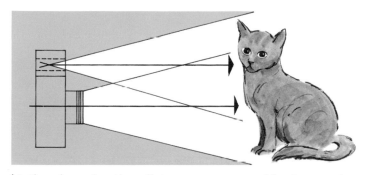

At the close shooting distances you use with close-up lenses, the viewfinder doesn't show exactly what will be in the picture, because the viewfinder is located slightly higher than the lens. This phenomenon is called "parallax." You can correct for parallax by tipping the camera slightly in the direction of the viewfinder after you have composed the picture. The closer you get to the subject, the more you need to tip the camera in order to get the picture you first saw in the viewfinder.

When you see this through the viewfinder . . .

. . . the picture will look like this. So tip the camera slightly to compensate.

Close-up Framing Device

It's easy to make a device that will both measure the distance to your subject and show you the subject area that will be included in your picture. The instruction sheet supplied with your close-up lens explains the subject distance, the width of the field size, and the focus setting for that close-up lens. Cut a piece of cardboard and draw a line down the center as shown.

A Subject distance

B Width of area included in picture at distance **A** (also height for square-format cameras)

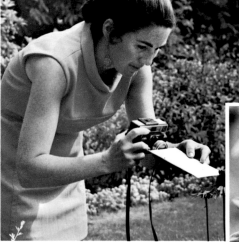

To make a picture, hold the cardboard straight out from the camera in front of the center of your close-up lens. Line up the subject so that it just touches the end of the card and fits within the width of the card. Drop the card and gently **squeeze** the shutter release.

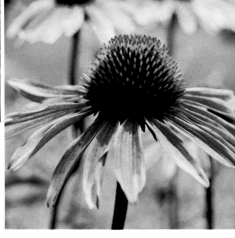

If you have a single-lens reflex camera, such as a KODAK INSTAMATIC Reflex Camera, you can see what will be in the picture when you look through the viewfinder. There is no parallax with this type of camera. When you peer through the viewfinder, you're actually looking right out through the lens that takes the pictures, and you can see whether the picture will be sharp and properly framed.

Lighting for Close-up Pictures

Usually, the most convenient way to make close-up pictures is in bright sunlight. Sunlight does create shadows, so check your subject to make sure that it is not in patches of shadow. If it is in a shadow, try to change your viewpoint so that most of the subject is sunlit; or use a large piece of white paper or aluminum foil to reflect sunlight into the shadows.

You can use flash for close-up picture-taking outdoors on overcast days or in the shade, as well as indoors. Because the flash is so close to the subject, you must cut down the amount of light, or the picture will be overexposed (too light). An easy way to do this is to drape a *white* handkerchief over the flash reflector or flashcube. Make sure that the handkerchief doesn't get in front of the camera lens.

If you have a fixed-focus camera, the table below tells you how many layers of white handkerchief to use over the flash reflector or flashcube at various distances with KODACOLOR-X, KODACHROME-X, or KODAK EKTACHROME-X Film and AG-1B flashbulbs, flashcubes, or magicubes.

SUBJECT DISTANCE	LAYERS OF WHITE HANDKERCHIEF
7½ inches	4 layers
1 foot	3 layers
1½ feet	2 layers
2 feet	2 layers
2½ feet	1 layer
3 feet	1 layer

This same table can also be used with adjustable cameras (and AG-1B flashbulbs or flashcubes) with the lens set at $f/11$.

With a KODAK INSTAMATIC 704, 714, 804, 814, or X-90 Camera, you can use a 3+ close-up lens to take flash pictures at a subject distance of 11⅛ inches. Set the focus scale at 6 feet and use three layers of white handkerchief over the flash reflector, flashcube, or magicube. If you use these cameras for close-up flash pictures at other distances, or with other close-up lenses, you may want to make your own test exposures.

FLOWERS

Thumbs come not only in an extensive variety of sizes but in all colors. Twice blessed, though, is he whose initial digit is green, for he has a communion with the soil that is akin to magic. Not only is he able to raise blooms of surpassing size and shape, but with almost any camera he can preserve their glory in close-up color pictures.

If you are among the chosen few, or even a mere digger-and-hoper, the next few pages should reveal a wonderful world of picture-taking pleasure.

Flowers may look rather unimpressive when they are snapped at normal distances . . .

. . . but with a close-up lens, you can move in close and fill your picture area with a few blossoms.

A Little Bit on Backgrounds

When you use a close-up lens, the background in your picture will be extremely out of focus. An out-of-focus background becomes a pleasant, hazy, unobtrusive curtain of color that complements the subject without distracting attention from it.

If you'd like your blossom to appear isolated against a plain black background, shoot with flash.

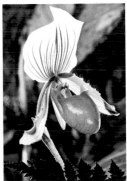

There's another method you can use to obtain a plain dark background. Hold a large sheet of black paper behind the subject and make a normal daylight exposure. The blossoms will stand out in sharp contrast.

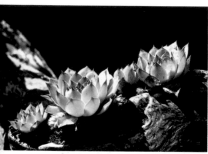

Black-paper background Normal, out-of-focus background

If there's no black paper handy, you might ask a friend to stand so that his shadow falls on the background. His shadow will cause the background to turn out underexposed and dark in the picture.

If you prefer a colored background, you'll find a rainbow selection of large sheets of dull-finish, colored paper at art-supply stores. Hold the paper behind the flower, and you have a portable background. Be careful that the flower doesn't cast a distracting shadow on the background paper.

When your target is the bloom of a potted plant, you can tape the background paper to a wall about a foot or two behind the subject.

Using Lighting

When the sun shines on blossoms from the back or side, it shows their texture and delicate, translucent beauty. So when you can, try to use backlighting or sidelighting.

Make Your Own Dew

Add impact to your flower pictures by sprinkling a little water on the blossom before you shoot. The water will give your flowers a fresh, dewy look that is pleasing in pictures.

Some flowers "put on a different face" with each season. For example, a jack-in-the-pulpit is green in the spring and a vibrant red in the fall. You can make interesting comparison pictures of flowers during several seasons.

If you're interested in flower arranging, you can make a picture book of ideas for arrangements. Take pictures of formal flower arrangements and keep them in an album. They'll provide you with ideas for years to come. Take pictures of your own arrangements as a record and to help interested friends.

Like many other prized possessions, these exquisitely carved figures are too valuable to carry around, but you can use well-made color pictures to show off their beauty to fellow enthusiasts.

IF YOU LIKE TO MAKE OR COLLECT THINGS

If you don't already have pictures of the items you make or collect, why not take some? It's easy to do, and the rewards are great. Pictures form the basis for a wonderful filing system for such things as rocks and mineral specimens, so you know exactly what you have and what condition it's in. Pictures can also provide a graphic inventory for insurance or appraisal purposes.

But most of all, you're probably proud of your collection. And sometimes the easiest way to show it off is through a series of well-made pictures.

Taking beautiful pictures of your prize collection is as easy as 1, 2, 3.

1 Use an uncluttered background. A piece of colored paper or cloth, such as velvet, makes a good background. Snap stamps and coins right in their own albums.
2 Move in close to fill your picture area with the object. Use a close-up lens for small objects.
3 Shoot your collection in the sun, or use flash indoors. Always shoot at an angle when objects are behind glass.

You may want to ask a friend to take a picture of you enjoying your collection so that other collectors will identify **you** with your prized items.

141

IF YOU DON'T HAVE A COLLECTION

Maybe you're not the least bit interested in collecting *things*. Why not increase your photographic enjoyment by collecting *pictures* of special classes of things—like animals, funny signs, foreign costumes, or architecture?

Sound like a corny idea? Not when you consider this: People with such collections get far more fun from their travels and their cameras because each new city, each untraveled road, is a potential storehouse of treasures passed up by the rest of the world. Some people collect pictures of churches and stained-glass windows. We know one man who "collects" covered bridges and shows them for pay to women's clubs and civic groups. Another man collects pictures of suspension bridges. Still another has a growing collection of those vanishing traces of early American architecture, rural outhouses!

Each of these people enjoys life and his hobby more because the world is full of special things to look for and photograph. Each new turn in the road may reveal an unexpected prize.

Collect Cars—in Pictures

Maybe you have a special interest in antique cars. You can't collect them all and keep them in your living room, but you can keep a picture collection of antique cars there.

Perhaps a picture collection of different types of acetylene headlamps would interest you, or pictures of as many different models and years of a certain make of car as you can find.

Antique-car owners are usually very proud of their cars and want to show them off. You'll probably find that they're most cooperative when you ask them about taking pictures of their cars. If a car is parked in an area with a distracting background, you might ask the owner to move his car to a better picture-taking spot. Foliage is nearly always a good background—after all, 1905 foliage didn't look any different.

Antique cars have many interesting parts—such as headlights, sidelights, antique-type speedometers, bulb horns, and acetylene generators. You can capture the small details of these parts in close-up pictures.

Paintings—the Easy Way

It would cost a fortune to purchase every beautiful painting you admire. For a few cents, you can enjoy these same paintings if you take pictures of them for your photographic collection.

The easiest way to take beautiful paintings home in pictures is to shoot with flash. To avoid glare from the flash, take pictures at a 45-degree angle to the painting. If you're taking pictures in an art gallery or museum, check to make sure that picture-taking is allowed.

If the gallery or museum does not allow flash picture-taking you may be able to shoot pictures with existing light if you have a camera with an $f/2.8$ lens. You'll need a high-speed film such as KODAK High Speed EKTACHROME Film (Daylight) if the light is from skylights or windows. For artificial light, use KODAK High Speed EKTACHROME Film (Tungsten). Since these low-light conditions call for a slow shutter speed, you may also need a tripod or other firm camera support. An automatic camera or exposure meter is the best method of determining the exposure when you take indoor subjects with existing light.

Browse at Home

If you enjoy browsing in quaint little shops that offer "treasures" from around the country or around the world, you might enjoy collecting pictures of one particular kind of "treasure." For example, many shops, from gift shops to antique stores, have colorful glassware beautifully displayed. Pictures of unusual glassware make an interesting collection.

Most people enjoy looking at the funny side of life. It's fun to take pictures of the humorous signs you see.

If you love nature, take pictures of wild things.

There are all kinds of things that make inspirational subjects for picture collections—bridges, fences, night scenes, landscapes, foreign cars, unusual architecture, interesting people, sunsets, and even mailboxes. *People collect things because it's fun. You'll find it's fun to make picture collections, too.*

146

remember....

- Take close-ups of flowers and other small subjects by using close-up lenses.

- Measure the distance from the front of the close-up lens to the subject.

- Correct for parallax by tipping the camera slightly toward the viewfinder.

- You can make a device that will measure the correct distance to your subject and show you how much will be included in your picture area.

- When you use flash for close-ups, you need to cut down the amount of light by putting a white handkerchief over the flash reflector or flashcube.

- Backlighting or sidelighting brings out the texture of flowers.

- Sheets of colored paper make colorful, plain backgrounds for close-ups.

- Sprinkle some water on flowers to give them a fresh, dewy look.

- Make pictures of the objects you make or collect.

- Collect pictures of special things that interest you— such as antique cars, paintings, glassware, funny signs, or unusual mailboxes.

WOULD YOU LIKE TO TRY
SOME OTHER PHOTOGRAPHIC TECHNIQUES?

So far in this book, we've talked about taking all kinds of pictures with equipment you probably already have. There are many photographic techniques that you can use to make your pictures even better and more interesting. Some of these techniques, such as using photolamps, do require some extra equipment, but the investment in equipment won't be very great. We've included these techniques in this book because they're fun. Maybe it never occurred to you that you could take a certain kind of picture with your camera. For example, those people who enjoy skin diving can actually take their cameras with them when they "go below." You'll find out more about this and other special techniques in this section.

USING FLASH OFF THE CAMERA

Using the flash off the camera helps you create an appearance of shape and dimension with shadows. Off-camera flash makes

more pleasing and natural pictures of people than flash on the camera.

Flash on the camera is the easiest and most popular method of flash picture-taking, but if your flash unit attaches to the camera with a cord, try holding the flash unit at arm's length, high and off to the side of the camera. When the flash is held off the camera, it throws less light on one side of a subject's face than on the other; this creates shadows and gives the subject an appearance of dimension.

Holding the flash off the camera demands a fair degree of manual dexterity, since you must operate the camera with one hand while you hold the flash with the other. The easiest solution to this juggling problem is to ask someone to hold the flash while you shoot.

Always figure your exposure for flash pictures on the distance from *flash* to subject, *not* camera to subject.

If you find your flash cord isn't long enough to hold the flash unit at arm's length, your photo dealer has a supply of inexpensive flash extension cords. Your photo dealer also has KODAK Publication No. AC-2, *Flash Pictures,* which describes other flash techniques, such as using several flash units at the same time.

 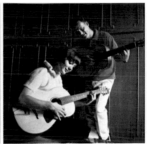 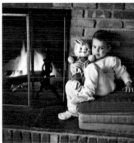

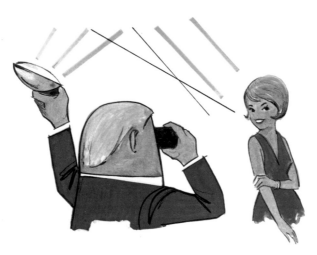

TRY "BOUNCING" THE LIGHT

The light hits the ceiling in this technique, which lets you duplicate the soft, hazy sunlight that makes possible such pleasant pictures of people outdoors.

If you have a white ceiling, you can bounce light off it. Aim your flash holder, photolamps, or movie light at the ceiling. The light will reflect from the ceiling and spread evenly throughout the room, producing a pleasing, natural type of light without harsh shadows.

Exposure for Bounce Flash

Since the light has to travel from the lamp to the ceiling and then to the subject, you need more exposure when you use bounce lighting. To get more exposure for bounce flash, you need to use a larger lens opening. Therefore, you can use bounce flash only with adjustable cameras. Exposure depends somewhat on the size and brightness of the room and the total distance the light has to travel from flash to ceiling and back down to the subject. In an average room, use about 2 stops more exposure for bounce flash than for direct flash at the same distance. In very large rooms or rooms of dark decor, try about 3 stops more exposure than for direct flash.

150

When you bounce light off the ceiling, the diffused light that reflects from the surroundings is soft and pleasing, similar to lighting outdoors on an overcast day.

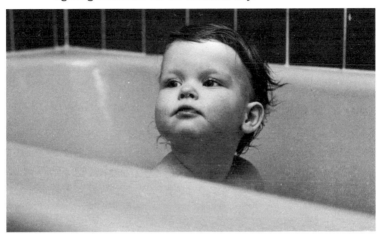

Here is another example of bounce lighting. Notice the extremely soft, even quality of the light.

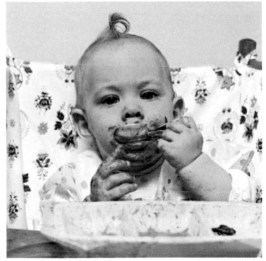

BOUNCE LIGHT WITH MOVIE LIGHTS AND PHOTOLAMPS

You can take pictures by bounce photolamp light with an adjustable or automatic camera. The subject isn't as brightly lighted as when the lights are aimed directly toward it, so use a fast film, such as KODAK TRI-X Pan Film for black-and-white prints or KODAK High Speed EKTACHROME Film (Tungsten) for color slides. If your camera isn't automatic, use an exposure meter to determine the correct shutter speed and lens opening. If you don't have a meter, try the settings in the table below. This table is based on the use of a 625- or 650-watt tungsten-halogen movie light aimed at a white ceiling. These same suggestions apply to a three-lamp movie light (using 300- or 375-watt reflector photolamps). If you use two 300- or 375-watt reflector photolamps, try a lens opening ½ stop larger than that shown in the table.

SUGGESTED EXPOSURES FOR BOUNCE LIGHTING

KODAK Film	Speed (ASA)	Shutter Speed	Lens Opening
For Black-and-White Prints			
TRI-X Pan	400	1/60 sec	f/4
VERICHROME Pan	125	1/30 sec	f/2.8
PLUS-X Pan	125	1/30 sec	f/2.8
For Color Prints			
KODACOLOR-X*	25	1/30 sec	f/2
For Color Slides			
KODACHROME II Professional (Type A)	40	1/30 sec	f/2
High Speed EKTACHROME (Tungsten)†	100	1/30 sec	f/2.8
High Speed EKTACHROME (Tungsten)† at 2½ times normal speed with ESP-1 processing‡	250	1/30 sec	f/4

*With a No. 80B filter.
†To obtain better color rendition, use a No. 81A filter.
‡See footnote on page 10.

USE TWO PHOTOLAMPS
FOR PICTURES WITH DEPTH

Bounce lighting has certain advantages, but direct lighting has advantages, too. Direct lighting is brighter than bounce lighting. Using photolamps is cheaper than using flashbulbs or flashcubes. Using several photolamps produces lighting that is more attractive than on-camera flash, because you can create highlight and shadow areas. Also, with photolamps you can *see* how the lighting looks before you take the picture.

By using two reflector-type photolamps, you can set up a simple but effective lighting arrangement. Place one light (the "fill-in" light) at the camera and another of equal intensity (the "main" light) higher and to one side. Place the main light closer to your subject than the fill-in light and at a 45-degree angle from the line between subject and camera. Because the

With photolamps, you can see how the lighting looks before you snap the picture.

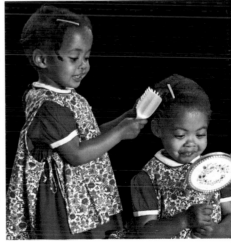

main light is away from the camera, part of the subject will be in shadow. This emphasizes the depth and shape of the subject (photographers call it "modeling"). You don't want the shadows to be too dark, so you use the fill-in light at the camera position to illuminate the shadows.

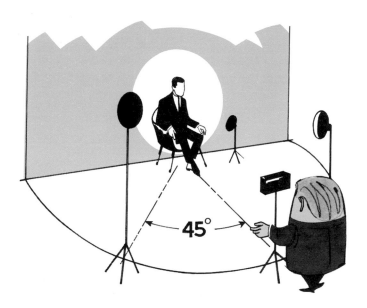

You can improve on the two-light system by adding a background light. Place the third light low and behind the subject, pointed at the background. Move this light closer or farther from the background to make the background lighter or darker. (The background should not be brighter than your subject.) The background light has no effect on exposure.

Exposure with Photolamps

If you have an automatic camera, you can just aim and shoot after you have the lights arranged. The best way to determine the exposure for an adjustable camera is with an exposure meter. However, if you don't have an exposure meter, the following table gives some suggested exposures.

SUGGESTED EXPOSURES FOR ADJUSTABLE CAMERAS

KODAK Film	Speed (ASA)	Shutter Speed	Reflector Photolamps (500 watt)	
			Main Light—5 ft Fill-in Light—7 ft	Main Light—7 ft Fill-In Light—10 ft
For Black-and-White Prints				
TRI-X Pan	400	1/125	between f/5.6 and f/8	between f/4 and f/5.6
VERICHROME Pan	125	1/60	between f/4 and f/5.6	between f/2.8 and f/4
PLUS-X Pan	125	1/60	between f/4 and f/5.6	between f/2.8 and f/4
For Color Prints				
KODACOLOR-X*	25	1/30	between f/2.8 and f/4	between f/2 and f/2.8
For Color Slides				
KODACHROME II Professional (Type A)	40	1/30	f/4	f/2.8
High Speed EKTACHROME (Tungsten)†	100	1/60	between f/4 and f/5.6	between f/2.8 and f/4
High Speed EKTACHROME (Tungsten)† at 2½ times normal speed with ESP-1 processing‡	250	1/60	between f/5.6 and f/8	between f/4 and f/5.6

*With a No. 80B filter.
†To obtain better color rendition, use a No. 81A filter.
‡See footnote on page 10.

The Photolamp Exposure Dial in the *KODAK Master Photoguide* (AR-21), available from photo dealers, gives exposure settings for other light-to-subject distances.

FILL-IN FLASH

Bright sunlight makes people squint. On page 36, we've already talked about asking subjects to move into the shade to avoid squinting. But, there's another way to avoid squints and to put a smile on a subject's face. Have your subject turn his back to the sun, and watch the squints disappear. When a subject faces away from the sun, his face will be in a shadow. You can use flash to fill in this shadow with light. This technique is called "fill-in flash."

Fill-in flash relieves subject squint and gives you round, pleasing modeling, similar to the results obtained in a portrait studio, where lights are used on both sides of the subject. The sunlight illuminates the back of the person, creating a halo of light around him that will show the texture of hair and clothing.

For Fill-in Flash with Simple and Automatic Cameras

Pop in a flashbulb, flashcube, or magicube, and take pictures in the 4- to 9-foot range.

For Fill-in Flash with Adjustable Cameras

Cameras with "X" Synchronization: Set the shutter speed at 1/30 second and use the lens opening that will give the correct exposure for a sunlit subject—for example, 1/30 second at $f/22$ for a film with a speed of ASA 64. With AG-1B and M2B flashbulbs, flashcubes, and magicubes, keep your subject within the 3- to 7-foot distance range. With 5B, 25B, and M3B flashbulbs, keep your subject within the 4- to 10-foot distance range.

Cameras with "M" Synchronization: Set your lens opening at $f/11$ and use a shutter speed that will give the correct exposure for a sunlit subject—for example, 1/125 second at $f/11$ for a film with a speed of ASA 64. Keep your subject within the 6- to 10-foot distance range.

The *KODAK Master Photoguide* (sold by photo dealers) contains fill-in flash tables which list recommended combinations of flashbulb, synchronization, shutter speed, and flash-to-subject distance.

COPY YOUR VALUABLE PICTURES

Have you ever wanted to make your own copies of certain prized pictures? If you have a negative, it's easy to order as many extra prints as you want from your photo dealer. Most photo dealers can have copies made directly from your prints, too, but some people think it's fun and rewarding to "do it themselves." You can copy photographs with your camera and a close-up lens. Pages 131 through 136 give the details on using close-up lenses.

The following table gives a list of the films you can use for copying:

Kodak Films for Copying

Film Name	Produces	Balanced for
KODACHROME II (Daylight)	Color Slides	Daylight
KODACHROME-X	Color Slides	Daylight
EKTACHROME-X	Color Slides	Daylight
KODACHROME II Professional (Type A)	Color Slides	Photolamps (3400 K)
High Speed EKTACHROME (Tungsten)*	Color Slides	Tungsten (3200 K)
KODACOLOR-X	Color Prints	Daylight
PLUS-X Pan	Black-and-White Prints	Daylight or Tungsten (3200 K)
VERICHROME Pan	Black-and-White Prints	Daylight or Tungsten (3200 K)
TRI-X Pan	Black-and-White Prints	Daylight or Tungsten (3200 K)

*See footnote on page 10.

158

Frequently, the most convenient light source for your copying will be sunlight—just move your copying setup into the backyard.

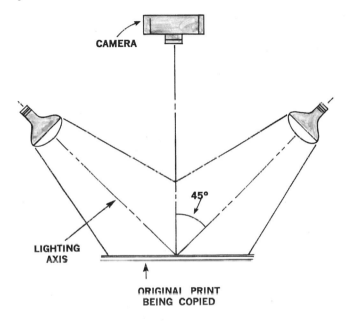

CAMERA

45°

LIGHTING
AXIS

ORIGINAL PRINT
BEING COPIED

Indoors, use a lighting setup like the one in the diagram. Two gooseneck lamps can be used for holding the lights. You can use ordinary household light bulbs for copying with black-and-white films. In order to obtain the correct color rendition with color films, it's best to use photolamps. The lamps should be of equal intensity.

Use an exposure meter to determine the exposure. For best results, always use a lens opening of $f/8$ or smaller with close-up lenses.

A fourteen-year-old boy
made this picture in
15 feet of water with a
KODAK INSTAMATIC
Camera.

160

YOU CAN TAKE PICTURES UNDERWATER
(Without Getting Your Camera Wet!)

The underwater world teems with colorful, graceful subjects for your pictures. If you're a skin diver, the underwater world presents unusual opportunities for picture-taking.

Adventurous swimmers go below with swim fins and snorkels or scuba gear—and they take their cameras with them to record the breathtaking sights below. Many types of underwater housings are available to keep your camera dry. One type, a molded plastic unit, is shown in the picture on the left. It holds an INSTAMATIC Camera and has a flash unit designed to work underwater. (This housing is available from Sea Research & Development Inc. of Bartow, Florida.)

Once you have your camera protected in a watertight housing, you're ready to take it below. Underwater pictures have a greenish or bluish tinge. Also, the deeper you go, the darker it becomes, until you find flash the only practical light source.

Things are magnified slightly underwater due to the refraction of light rays. Underwater photographic "feet" are only 9 inches long. Subjects appear larger, and you won't have to get as close to them to fill your picture area as you would on land. With simple housings, you can't use the viewfinder. All you do is point the camera and shoot. If you can use your viewfinder and rangefinder, they're subject to the same influences as the taking lens.

The Right Exposure

Exposure of pictures underwater depends on lots of things—
the angle of the sun, the clarity of the water, depth, the color
of the bottom, and the nearness of the subject. An automatic
camera takes all these variables into consideration and will
give you good exposure. If you don't have an automatic cam-
era, it's best to use an exposure meter (enclosed in a watertight
housing, of course). Unless your camera has a "fast lens," such
as an $f/2.8$ lens, you'll need to use flash when you take pictures
deeper than 5 feet. If you don't have an automatic camera or
exposure meter, you can use the following table as a *guide* to
setting your camera for underwater picture-taking.

The table below lists exposures you can use as a starting point with adjustable cameras. We recommend that you bracket these exposures. The suggestions in this table are based on a bright, sunny day, between 10:00 a.m. and 2:00 p.m., with winds blowing slightly, and with an underwater visibility of about 50 feet.

EXPOSURE COMPENSATION FOR UNDERWATER PHOTOGRAPHY

Depth of Subject	Number of f-stops to Increase Lens Opening Over Normal Above-Water Exposure
Just under surface	1½ f-stops
6 feet	2 f-stops
20 feet	2½ f-stops
30 feet	3 f-stops
50 feet	4 f-stops

The most common shutter speeds for underwater picture-taking are from 1/60 to 1/125 second. If lighting conditions are bright enough, use 1/125 second. This helps eliminate the effects of camera movement due to underwater currents.

Prefocus your camera before you go below. For small subjects, set the focusing scale for 2 or 3 feet. For larger subjects, focus at 6 feet, and make pictures only at the appropriate distance. Since refraction affects your eyes in the same way as it does your camera, judging distance should not be a problem.

You can use KODACHROME II, KODACHROME-X, KODAK EKTACHROME-X, or KODAK High Speed EKTACHROME Film for color slides; KODACOLOR-X Film for color prints. Use KODAK TRI-X Pan, PLUS-X Pan, or VERICHROME Pan Film for black-and-white prints.

For adventure, challenge, fun, and good pictures—try taking your camera underwater with you.

CONTROLLING COMPOSITION

Perhaps you've mastered the following tips from the section "Making Ordinary Pictures into Good Pictures":

- Look around for the best background.
- Include one center of interest.
- Keep the horizon straight.
- Look over the picture for attention stealers.

In that case, you may want to go a bit further and aim for really outstanding photographs. By being careful about composition, you can make your pictures more attractive. It's not hard, but it does take a little extra thought and effort at first. (Most worthwhile things do take a *little* extra effort.) There are several things that you might want to keep in mind when you compose your next picture.

Place Your Center of Interest Off Center

Pictures look less static and more pleasing when the subject is slightly off center. Mentally divide the scene into thirds, both vertically and horizontally. Place your center of interest at one of the four places where the lines intersect. Of course, "rules" like these are made to be broken—some subjects look good when they're centered in the picture area. But most often, an off-center composition looks best.

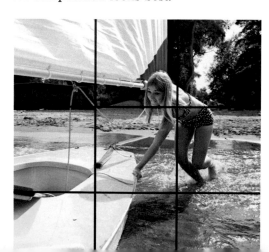

The tree in the foreground makes a natural frame for this mountain peak. A frame creates a feeling of depth in a scene and directs your attention to the center of interest.

Take Pictures Through Frames

We mentioned this in the travel section, but it can do so much for your pictures that we think it's worth mentioning again. We're talking about a frame within the picture. This kind of frame is an object close to the camera; it borders the subject on at least one side and sometimes surrounds the main subject entirely. Use trees, fences, windows, or any appropriate opening that you can shoot through. Your pictures will have a feeling of depth, because the frame is closer to the camera than the main subject.

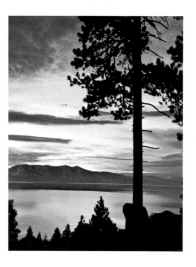

Place the horizon high to suggest closeness.

Place the horizon low to suggest spaciousness.

Use the Horizon Line as Composition Control

Put the horizon high or low in the picture—try to avoid cutting your picture in the middle with the horizon line. (Of course, you'll keep the horizon straight so that your scene won't appear to be sliding off the picture.)

Roads and fences make good leading lines for scenic pictures.

Use Leading Lines to Direct Attention into Your Pictures

Try to select a point of view where the natural lines of the scene will lead your eye into the picture and toward your main center of interest.

Sometimes you can capture a shadow and use it to direct attention toward your center of interest.

Try controlling the composition in your pictures—soon you'll find that using these techniques will be "second nature" to you—your good pictures will show it!

remember....

- You can create an appearance of shape and dimension in your flash pictures by taking the flash off the camera and holding it high and to one side.

- You can get very soft, pleasing lighting for pictures of people indoors by bouncing light off the ceiling.

- For portraits indoors, use two photolamps; place one light high and to one side and place the other light at the camera.

- Use fill-in flash to create pleasing lighting and pleasant expressions when you photograph people in sunlight.

- You can put your camera in a watertight housing and take pictures underwater.

- Controlling the composition of your pictures will make them more attractive.

SHOWING OFF YOUR SLIDES

Color slides are made to be shown, even shown off. When they are well shown, they can be very effective and provide enjoyable entertainment. If you plan to project some of your slides for a group, make sure that the slides will be entertaining by taking a few minutes to organize them into some logical sequence—not necessarily the order in which they were taken. Show only sharp, well-exposed slides. Try to select pictures as interesting to others as they are to you. Simple thoughtfulness like this will assure that your friends will look forward to enjoying your slide shows.

An inexpensive slide sorter such as this one is a great help in selecting slides for a show and putting them in the right sequence.

If you want to be a real showman, add interest to your slide show by using title slides. (See the "Travel" section for information about title slides.) Make sure your slides are in the correct order and oriented so that they'll be right side up on the screen. For convenience, some people put a "thumb spot" on the lower left corner of each slide mount (with slide image right side up). Self-sticking thumb spots are sold by photo dealers. Turn the slide so that the thumb spot is in the upper

right-hand corner of the mount when it goes into the projector; the slide will then be properly oriented when it is projected on the screen.

Place the thumb spot in the lower left-hand corner of the slide mount.

Turn the slide so that the spot is at the upper right when you put it into the projector.

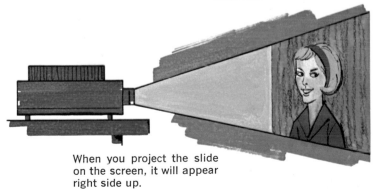

When you project the slide on the screen, it will appear right side up.

Before the show (and before the audience arrives), set up the projector and screen. Place the screen far enough away from the projector for each projected slide to fill the screen. (Keep an extra projection bulb on hand so that you won't have a disappointing blackout in the middle of a show.) Focus your first slide, and you are ready to start. Music from a phonograph or tape recorder makes a nice background for a slide show. Do your audience a favor by turning on the projector before you turn off the room lights. Finally, keep the show's length down to an hour or less. Popcorn anyone?

WHICH TYPE OF SCREEN IS BEST?

If you're shopping for a projection screen, you'll find that there are many types of screens on the market. The two most common types are lenticular screens and beaded screens.

Lenticular screens have a patterned surface which reflects the light from the projector evenly over a wide, fan-shaped area. This type of screen is good for projecting slides in most "living room" situations, because the audience can sit almost anywhere in the room and still see a bright picture on the screen.

Beaded screens have a white surface covered with small, clear glass beads. Most of the light projected onto a beaded screen is reflected back toward the projector, which makes a beaded screen useful in long, narrow rooms or other locations where most viewers are near the projector beam.

Aluminum screens, such as the KODAK EKTALITE Projection Screen, Model 3 (40 x 40), are made of a specially treated aluminum foil which has been laminated to a curved molded housing. This type of screen is often called a "daylight" screen because it directs virtually all the projected light back to the audience, and it can be used in daylight or in normal room lighting. Because the screen is slightly curved, any hot spots are eliminated, and the images are exceptionally sharp due to the smooth screen surface. The screen is rigid so it cannot be folded or rolled up for compact storage; however, it comes with a bracket so it can stand on a table or be mounted right on the wall.

MAKING AN INTERESTING PHOTO ALBUM

A photo album is a chronicle of a family's activities. It's always fun to look through the album and see what the family looked like, what style of clothing was worn, and what activities were enjoyed in the years gone by.

You can make your album more interesting by putting your pictures in storytelling order. Identify the pictures with captions. Elephants may have long memories, but people don't. If you plan to type your captions, you'll find adhesive-backed, pressure-sensitive paper an ideal medium. It winds into a typewriter just as any ordinary paper does. After typing captions, cut them apart, remove the protective backing, and press the captions into their proper positions. Many art-supply and stationery stores carry this material.

To mount prints in the album, use an adhesive such as Kodak Rapid Mounting Cement, made specifically for this purpose. Many ordinary adhesives have ingredients that cause photographic prints to fade. Be sure the adhesive you use is safe.

PHOTOGRAPHIC GREETING CARDS

Another way to capitalize on your best pictures is through photographic greeting cards.

By far the most widespread use of photo-greeting cards is at Christmastime. We mentioned this briefly in the section on baby pictures. Nearly everyone has people on his greeting list who are seen less frequently than he'd like. A photographic card, by including a special personal touch, adds an extra measure of warmth to the seasonal wishes you extend to these people. These cards are especially valued when there are children in your family. A picture, as nothing else, keeps your friends closely in touch with the growing-up process.

All that's needed for a good photo-greeting card is a good negative, slide, or print. Your photo dealer will help you select a greeting-card design and will take care of the details for you— even to supplying the envelopes.

DISPLAY YOUR PRINTS

There are many beautiful frames on the market for prints of any size. Frames show off your enlargements and help preserve their beauty by keeping them flat and protected. Keep the glass in a frame from being in direct contact with a color print, or remove the glass altogether.

Flush mounting is simple and modern-looking. It allows you to hang pictures without frames.

You can use enlargements for a picture wall or room divider.

You can mount your enlargements on heavy art board for display. Art-supply stores carry heavy mounting board in a variety of colors. With KODAK Dry Mounting Tissue, and an ordinary iron, you can mount enlargements yourself. Follow the directions that come with the mounting tissue.

Display Your Pictures and Show Your Slides Often—Everyone Enjoys Good Pictures!

ORDER ADDITIONAL SLIDES, PRINTS, AND ENLARGEMENTS

You can have additional color slides, prints, and enlargements made from your color slides. From any color negative you can get color prints, enlargements, slides, or black-and-white prints. See your photo dealer; he'll order the slides and prints for you.

A good negative or slide will yield a good enlargement. In ordering an enlargement, you can often obtain better composition than in the original picture, by cropping the negative or slide. This involves making your enlargement from less than the full picture area by cropping in from one or more sides. Take your negative or slide to your photo dealer. He has transparent "masks" that you can hold over your negative or slide

This print can be improved by cropping.

Before you order an enlargement, check with two "L's" to see if cropping will give you a better picture.

to see how much cropping you want to do. Your dealer will help you with the cropping, and order enlargements for you.

Remember that a print can always be replaced if you still have the original negative or slide in good condition. Negatives and slides, though, are virtually irreplaceable and should be carefully safeguarded. Negatives can be safely kept either in special negative files sold in most camera shops, or in the envelopes returned to you by your dealer. Slides can be kept in trays, special files, or the boxes returned by your dealer. The vital point is that negatives and slides should be handled only by the edges and should be stored in a cool, dry, dark place.

FROM ROLL FILM NEGATIVES

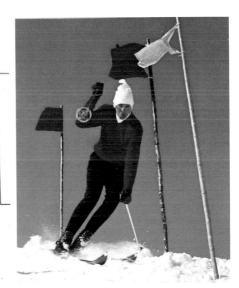

Your photo dealer has negative masks like this one, and he will help you order the cropping you want.

Cropping helped to concentrate the interest on the subject and gave this picture more impact.

UNSHARP PICTURES— FUZZY IMAGES

• Camera movement when the shutter was clicked. Hold your camera steady and gently squeeze shutter release.

• For normal picture-taking, be sure camera shutter is not set for B (bulb), T (time), or L (long), if your camera has such a setting.

• Camera too close to the subject.

Camera movement during exposure.

Hold camera steady.

has it
happened to you?

- Focusing scale on camera not set for correct subject distance.

- Shutter speed not fast enough to stop the action. With an adjustable camera, use a high shutter speed such as 1/250 or 1/500 second for moving subjects.

Too close, or wrong camera focus.

Focus camera sharply.

• If your subject is moving very fast or you can't use a high shutter speed to stop the action, follow the action by keeping the subject centered in your camera viewfinder as you take the picture—this is called "panning"—or change position so the action moves toward your camera.

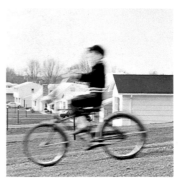

Subject motion; shutter speed too slow.

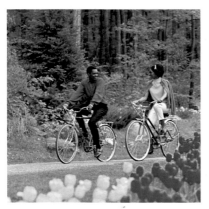

You can stop action with a high shutter speed—1/500 second.

You can "pan" your camera to follow subject—normal shutter speed.

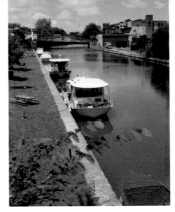

Dirty lens. Clean lens.

FOGGY, MISTY PICTURES

Caused by dirty lens or filter. Clean lens or filter with lens-cleaning paper—*not the treated kind for eyeglasses*—or a clean, soft, lintless cloth.

SLIDES TOO DARK—PRINTS DARK AND "MUDDY"

• Not enough light for picture-taking with a simple camera. See camera instruction manual.

• Too high a film-speed number used with exposure meter or automatic camera, if camera has film-speed dial. Use correct film speed as shown on film instruction sheet or film carton.

• Lens opening too small, shutter speed too fast, or both. See film instruction sheet for exposure suggestions.

• See "FLASH PICTURES."

Underexposure — not enough light, or lens opening too small or shutter speed too fast. Normal exposure.

179

SLIDES TOO LIGHT—PRINTS "WASHED OUT" AND CONTRASTY

• Obstruction over exposure meter window in camera.

• Too low a film-speed number used with exposure meter or automatic camera, if camera has film-speed dial. Use film speed shown on film instruction sheet or film carton.

• Lens opening too large, shutter speed too slow, or both. See film instruction sheet for exposure suggestions.

• See "FLASH PICTURES."

SLIDES BLACK—NEGATIVES COMPLETELY CLEAR (not printed) DUE TO LACK OF EXPOSURE

• Camera shutter didn't open.

• Flash didn't go off—see "FLASH PICTURES."

• Film not properly loaded in camera, so film did not advance through your camera.

• Unexposed film sent for processing. Avoid confusing unexposed with exposed 35mm film by rewinding it completely into magazine after taking last picture.

• Lens cap not removed.

Overexposure—something over exposure meter window. Lens opening too large or shutter speed too slow.

Normal exposure.

FLASH PICTURES

Proper exposure is based on flash-to-subject distance. See flash information on flash holder, camera, film instruction sheet, or flashbulb carton.

Flash Failure

● **Cameras That Use Flashcubes or Flashbulbs (not Magicubes).** Flash didn't go off, or went off late. Most frequent cause—battery contacts need cleaning or batteries are weak or dead. To clean battery ends and contacts in camera or flash holder, rub with a cloth dampened with clean water only. If contacts are difficult to reach, use a water-dampened cotton swab to clean them.

Use live batteries. Have them tested regularly and replace weak ones. If flash cord has screw-on adapter, make sure it's tightened.

● Faulty flashbulb; try another bulb.

● Camera's flash mechanism in need of repair.

● **Cameras That Accept Magicubes.** Faulty magicube; try another one.

● Camera's flash mechanism in need of repair.

Pictures Too Light

● Too close to subject with a simple camera or used the wrong cube for flash, such as a Hi-Power cube, at too close a distance. The typical flash distance range for a simple camera with a flashcube or a magicube is 4 to 9 feet; with a Hi-Power cube, 5 to 12 feet. See camera manual or flashbulb carton. (*Caution:* Use *only* magicubes on cameras designed to accept them.)

● Lens opening too large with an adjustable camera because flash-to-subject distance was overestimated or wrong guide number was used. Use rangefinder, or measure distance. See film instruction sheet or flashbulb carton for proper guide number.

Overexposure—too close with simple camera or lens opening too large.

Pictures Too Dark

• Too far from subject with a simple camera. See camera manual or flashbulb carton.

• Lens opening too small with an adjustable camera because flash-to-subject distance was underestimated or wrong guide number was used. Use rangefinder or estimate distance more accurately. See film instruction sheet or flashbulb carton for proper guide number.

• With an adjustable camera, the wrong shutter speed or synchronization setting was used for your type of flash. Check your camera manual.

Glare Spots—*See next page.*

Glare Spots

Shiny surfaces such as windows, mirrors, eyeglasses, and even shiny woodwork will reflect the flash and cause glare spots in your pictures. To avoid flash reflections, stand at an angle to the shiny surface when you take the picture instead of trying to take it head on.

Red Eyes

Red or amber spots in pupils of subject's eyes are caused by reflections of the flash in the eyes. In black-and-white pictures, the reflections in eyes look white. Minimize the red-eye effect by using a flashcube extender or a detachable flash holder to increase the distance between the flash and the camera lens. Another way to minimize the red-eye effect is to turn on all the room lights, causing the subject's pupils to contract. This reduces the intensity of the reflected light that causes red eyes in pictures, because less light is let into and out of the eyes.

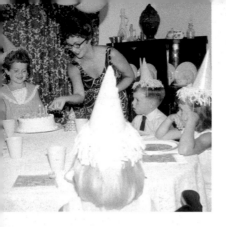

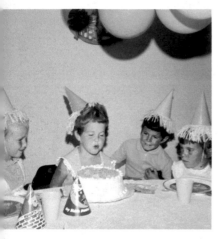

Uneven Exposure in Flash Pictures

Since flash exposure depends on flash-to-subject distance, subjects at different distances in group photos will appear lighter or darker depending on how far away they are from the flash. The people close to the flash receive too much light and those too far away receive too little light. You'll get more even exposure if all subjects that appear in the picture are about the same distance from the flash. Having the subjects closer together makes the picture more interesting to look at, too.

BLUISH OR REDDISH-ORANGE PICTURES

• Film designed for tungsten light used in daylight without filter. See film instruction sheet for filter recommendations, or use daylight film.

• Film designed for daylight or blue flash used with clear flash, photolamp light, or existing tungsten lighting (regular light bulbs). Use blue flash; follow filter recommendations on film instruction sheet; or use film designed for the photolamp or tungsten illumination.

Tungsten film used in daylight.

Normal results—tungsten film used with recommended filter.

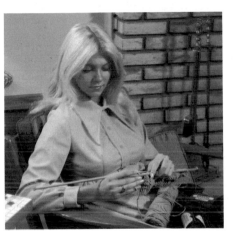

Daylight film used with tungsten light.

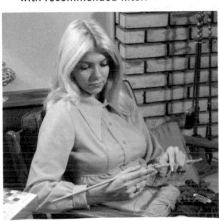

Normal results—daylight film with recommended filter.

WEAK GREENISH OR REDDISH PICTURES—
may have mottled appearance

• Film possibly outdated. Always check date on film carton. Use film before expiration date.

• Film possibly stored where it was hot or humid. Store film where it's cool and dry; have it processed promptly.

Film outdated or improperly stored.

PICTURES OVERLAPPED

• Film not advanced fully to next picture or to "lock" position.

• Too many pictures taken on roll. Last two photos overlapped.

• Film-winding mechanism in camera needs adjustment.

BLACK SPOTS ON PICTURES

• Dust, lint, or fragments of film inside camera. Brush inside of camera with camel's-hair brush or blow it clean with a small rubber syringe.

• Camera strap, front of camera case, or finger in front of lens.

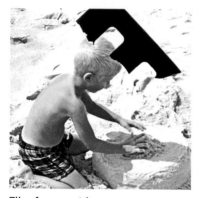

Film fragment in camera.

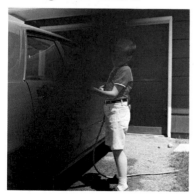

Camera strap in front of lens.

LIGHT STREAKS AND SPOTS

• Direct rays of sun or other bright light on lens.

Film Light-Fogged—

• Camera back opened with film in camera (light-sensitive part exposed to light).

• Light leak in camera.

• Film handled in bright daylight.

• Extreme camera movement during exposure.

• Shutter sticking, staying open longer than normal. Camera in need of repair.

index

FOR MORE INFORMATION—

Home Movies Made Easy (AW-2) $1.95
Explains thoroughly how to make good-quality, entertaining amateur movies.

Picture the Fun with Your KODAK INSTAMATIC Camera (AC-1) 75¢
For INSTAMATIC Camera owners who want to take good pictures of such fun things as parties, sports, people, pets, and many more.

Good Color Pictures—Quick and Easy (AE-10) 75¢
Here's the book for the amateur who wants good color pictures but doesn't want to spend much time and effort learning photography.

Kodak Pocket Guide to Good Travel Pictures (AC-19) 50¢
A pocket-size guide with on-the-spot information about how to take interesting travel pictures.

Basic Developing, Printing, Enlarging (AJ-2) 75¢
A simplified approach to darkroom work for beginners.

Better Movies in Minutes (AD-4) 75¢
Tells simple ways of making interesting color movies.

Flash Pictures (AC-2) 95¢
Techniques for making better flash pictures with black-and-white and color films.

Here's How (AE-81) 95¢
Ideas from the experts on subject control, exposure meters, night photography, making pictures in bad weather, and photographing nature, glassware, fluorescent minerals, and tabletops.

More Here's How (AE-83) 95¢
Knowledgeable articles on lenses, titling, multiple flash, composition, shooting the stars, getting the most from color-negative film, and building a photographic blind for nature photography.

The Third Here's How (AE-84) 95¢
Techniques for photographing children and wild flowers, slide manipulation, "pushing" color film, flash and travel, and the Kodak Colorama.

The Fourth Here's How (AE-85) 95¢
Articles on movie lenses, color printing, print finishing, slide duplication, slide-tape talks, and photographing antique cars.

The Fifth Here's How (AE-87) 95¢
Covers pictorial lighting, underwater photography, photography from the air; plus photographing cats and dogs, flowers, and glassware.

The Sixth Here's How (AE-88) 95¢
More ideas from the experts on photographing insects, the art of seeing, candid photography, photographing the dance, creative movie editing, and creating new pictures from old negatives.

The Seventh Here's How (AE-90) 95¢
Articles on infrared photography, top-quality slide projection, color of motion, decorating with photographs, time-lapse movies, and mood photography.

KODAK Films for the Amateur (AF-1) $1.25
Information about Kodak color and black-and-white films that will help you achieve top picture quality.

Enlarging in Black-and-White and Color (AG-16) 95¢
Information on selecting paper, printing, processing, print-finishing techniques, and printing controls.

KODAK Master Photoguide (AR-21) $2.50
A complete pocket-sized guide for the advanced photographer. It contains dial computers, tables, and text on exposure, filters, lenses, and photographic techniques.